IMAGES
of America

WHITES CREEK

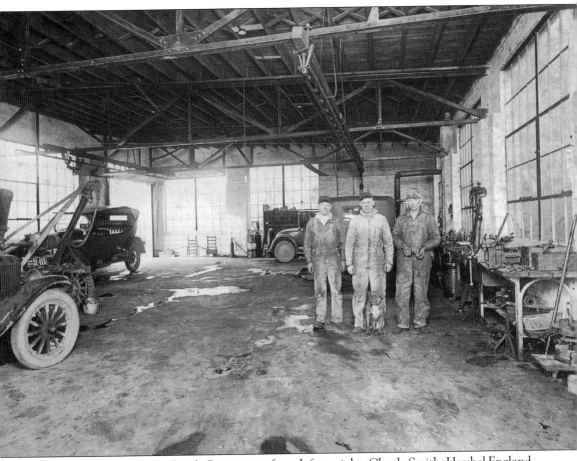

Seen inside the Whites Creek Garage are, from left to right, Claude Smith, Hershel England, and Miller Tinsley Sr. (Courtesy of Angela M. Hazel/England estate.)

IMAGES
of America

WHITES CREEK

Thomas B. Oliverio
Foreword by Marsha Stenberg Murphy

ARCADIA
PUBLISHING

Published by Arcadia Publishing
Charleston, South Carolina

Printed in the United States of America

Library of Congress Control Number: 2018932454

For all general information, please contact Arcadia Publishing:
Telephone 843-853-2070
Fax 843-853-0044
E-mail sales@arcadiapublishing.com
For customer service and orders:
Toll-Free 1-888-313-2665

Visit us on the Internet at www.arcadiapublishing.com

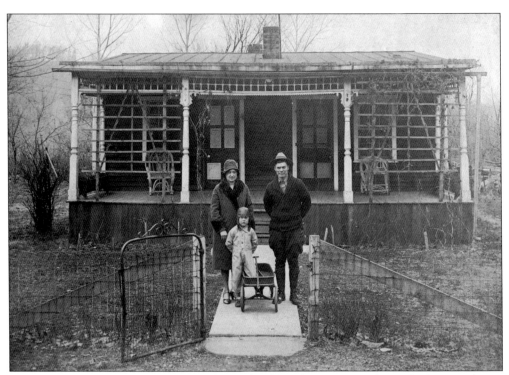

Owners of the Whites Creek Garage, the England family, are pictured outside their residence, which was located next door. (Courtesy of the England estate.)

CONTENTS

FOREWORD

The mission of the Whites Creek Historical Society is to identify, preserve, and disseminate the history of the Whites Creek watershed and its community. Located in the rolling green hills of Tennessee, this area was home to Native Americans thousands of years ago, as well as the first settlers of Nashville in 1779.

Monthly meetings provide a setting for neighbors old and new to gather and tell stories or listen to knowledgeable speakers. In one such meeting, a young man strode in and offered to compile a book about Whites Creek—what a surprise and a joy!

Thomas Oliverio, a six-year resident of the community, was struck with the beauty and history of Whites Creek and offered to help meet our goal. As an accomplished creative producer, Thomas recognized that Whites Creek needed its place in history recorded for the future generations who might call it home.

Thomas has used his artistic eye to bring nature's melody to these glimpses into the everyday life of our unique gem, surrounded by the Highland Rim on the outskirts of Nashville. We are grateful and thankful for this young man of many accomplishments to make this book one of those endeavors.

—Marsha Stenberg Murphy
Whites Creek Historical Society

ACKNOWLEDGMENTS

Special recognition goes to Marsha Stenberg Murphy for assisting with this project, which could not have been completed without her extensive contributions. Thanks to local historian Linda Thompson Jarrett and the Thompson family for preserving and allowing me access to their home and library, as well as assisting with editing and reviewing this manuscript for publication; Lynn and Judy Johnson for hosting the Whites Creek Historic Society meeting each month at their 1880s farmhouse; and Angela B. Williams, Gene Carney, Jeremy Stephens, Georgiana Burton Johnson, Angela M. Hazel, Marcie Hudson, Dennis Bobel, Sandra Capps Reinhardt, George Ewing, Patsy and Randy Gupton, and Austin Burton for sharing and gathering photographs and information both included and not included in this text. I would also like to thank Robert Ekman, general manager of Fontanel, for introducing me to the Whites Creek Historical Society, and Caitrin Cunningham, senior title manager at Arcadia Publishing, for her endless patience and support in completing this project. While I hope that this book gives readers a glimpse into the history of the community, it is not a definitive collection of photographs or interesting characters and stories from the area. If you would like to learn more about the region, find the valuably sourced John P. Graves 1985 book *Northwest Davidson County—The Land, Its People: Historical Sketches of Bordeaux, Jordonia, Scottsboro, Bell's Bend, Joelton, Whites Creek, Union Hill, Lickton, Bull Run, and Marrowbone*, and Paul Clements's 1987 *A Past Remembered: A Collection of Antebellum Houses in Davidson County*. In addition, information gathered from Whites Creek Historic District's 1984 National Register of Historic Places application proved to be a vital resource in compiling this text.

INTRODUCTION

The Whites Creek Historic District is part of a rolling valley alongside Whites Creek, where the Central Basin of Middle Tennessee meets the Highland Rim, just on the outskirts of the Cumberland Mountains. Once a part of Washington County, North Carolina, this land was given to Tennessee in 1790. Tennessee became a state in 1796, although the area had been occupied by Native Americans for thousands of years, with the Cherokee and Chickamauga thriving here through the late 1700s. Whites Creek provides a dramatic landscape of steep, wooded slopes defined by a natural boundary of tributaries, historically providing fertile land for Native Americans and those given land grants for service in the Revolutionary War. When settlers moved into this area, teeming with buffalo, deer, and elk, the natives felt threatened that their homeland would be taken or exploited. In 1781, the tension between the Native Americans and the settlers culminated in the Battle of the Bluff.

Today, the district still contains numerous buildings, rural in character, dating from the 1830s to the 1950s. Five of these buildings witnessed the Trail of Tears in 1838. They include large farmhouses, workers' cottages, early-20th-century bungalows, outbuildings, barns, churches, stores, a bank, and a garage. Architectural styles represented include vernacular farmhouse, Italianate cottage, turn of the century, Colonial Revival, bungalow, and English cottage. Typical building materials used were wood, brick, stone, and stucco. The heart of the district is at the intersection of Whites Creek Pike and Old Hickory Boulevard, where the stores, bank, garage, and two workers' cottages were located.

Whites Creek, one of the first areas settled in Davidson County, has maintained its rural character and has been continually used for agricultural purposes since its settlement in 1780. In the spring of 1779, James Robertson led an exploration party of nine to the part of Middle Tennessee that would become the city of Nashville. Members of the party camped together until the spring, then independently searched the surrounding wilderness to claim their various stations of land. Frederick Stump, a member of the party and signer of the Cumberland Compact in 1780, settled on Whites Creek immediately upon his arrival, and others joined shortly after. Also among these settlers was Zachariah White, who had come from North Carolina via Pennsylvania. White was believed to have been Nashville's first teacher and a part of the group left by Robertson at French Lick (also known as Fort Nashborough). He was killed April 2, 1781, in an Indian raid at the French Lick stockade where he was serving as a school teacher. Whites Creek was named for him, possibly due to having given his life at the Battle of the Bluff. It is also believed that he was the husband of Nashville's famous frontierswoman turned tavern and inn owner Granny White, namesake to Granny White Pike in Nashville.

Frederick Stump arrived with James Roberson's group on Christmas Eve 1779 after living an infamous life surviving a slew of hardships and battles. He and his wife, Anna Snavely, escaped the French and Indian War, although a number of their children were horrifically killed. They escaped to Georgia where he became a wealthy and influential miller and landowner. Stump was

over 50 years old at the beginning of the Revolutionary War but still served as a commander and participated in battle. He escaped from a war prison and returned home to find that his property had been burned down. Packing up his family once more, he traveled through the Appalachian Mountains toward the Cumberland River. Stump continued a lifelong war with the natives immediately upon arrival after losing his oldest son, 22-year-old Jacob Stump, to local Indians the spring after settling. By 1785, Stump had acquired 640 acres on Whites Creek. At that time, he co-signed a note for the establishment of a ferry (the second across the Cumberland River), which would connect Nashville to a road leading through his land to Clarksville, opening the way for settlement of the area. Eventually, Stump owned approximately 2,400 acres alongside Whites Creek, where corn and cotton were the main crops. Stump was also a captain in the state militia and in Natchez, as part of the military presence on hand when the Louisiana Territory was transferred from France to the United States in 1803.

Other settlers began acquiring land in Whites Creek after 1785, and the area quickly developed into one of Nashville's earliest communities. The Whites Creek Turnpike Company was organized and began construction in 1830, completing the road 14 years later. In 1849, the Buena Vista Turnpike Company began; that road was completed around 1857. The Whites Creek Post Office was established in 1877. In 1880, the community opened a school, which was bought by the county in 1887 and named for Alex Green, a local Methodist pastor and key figure in bringing Vanderbilt University into existence in 1874, as well as relocating the Methodist Publishing House to Nashville.

James B. White, the proprietor of the Whites Creek General Store, formed the Whites Creek Bank and Trust Company with five partners in 1911. The bank survived the Depression and began to prosper with the area dairy farms and the industrialization of the county. In 1948, the bank had holdings of over $1 million, and a new building was constructed, turning the old building over to the post office, which was located there until the 1960s.

Whites Creek has thrived as an agricultural community since its settlement. In the 19th century, the district consisted of several plantations, including those owned by the Marshall and Earthman families. Corn, small grains, and vegetables were the main crops grown until the 1920s. Soon after, dairy farming became the predominant agricultural activity, with as many as 20 dairies operating in the 1900s including those belonging to the families of Fred Johnson, Oliver Jones, Jack Burton, Alvin and Gene Parrish, Herman Thompson, Jack Teasley, Count Boyd II and III, Walter Gasser, Z.T. Parrish, Dan McCool, Cecil Talley, Tub Jackson, Buzzard Jackson, Dr. Daily, Scott True, Glenn Mowry, L.P. Smith, Miss White, Ronnie Brown, and Preston Keathley. Thompson's Country Maid Dairy was the most successful of these dairies and operated into the 1970s, supplying milk to Davidson County schools as well as local businesses and also providing home delivery.

The buildings of Whites Creek represent a wide variety of architectural styles, ranging from the 19th-century Tennessee vernacular styles to the revival styles of the early 20th century. The Yarbrough House is an excellent example of a Tennessee vernacular structure designed for use as an inn. The farmhouse at Old Hickory Boulevard is an example of a small vernacular farmhouse. The Bysor-Thompson House combines the massing of the vernacular style with turn-of-the-century detailing. The Victorian era is represented by the simply styled Italianate Jackson-Page House, the vernacular Victorian Earthman Store/Saloon, and the Eastlake Earthman House. The turn-of-the-century style is illustrated by the Bysor-Thompson House, as mentioned previously, with its alterations. The Whites Creek Bank and the Whites Creek General Store are commercial examples of this style. The White-Johnson House and the James B. White House are representatives of the bungalow style, as are the two smaller workers' cottages at 4500 and 4506 Whites Creek Pike. Whites Creek has several structures designed in the revival styles of the early 20th century. The Teasley House and the White-Tarpey House are mirror images designed in the English Cottage style, and Alex Green School is an excellent example of the Colonial Revival style.

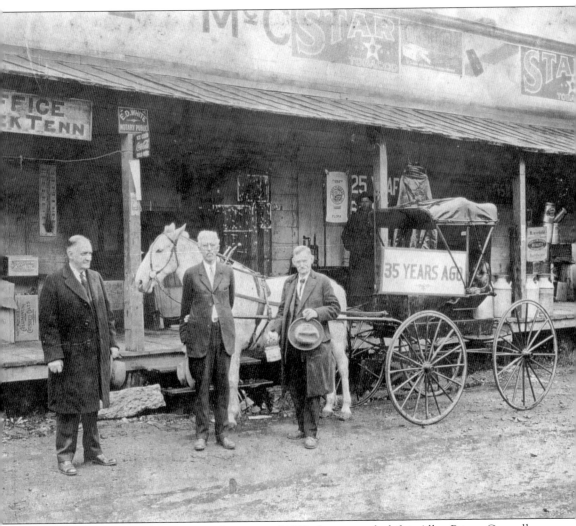

Whites Creek General Store is seen here around 1910; the man at far left is Allen Prince Connell, great-grandfather of contributor Angela Williams. The man next to him is Eli White, who served as postmaster, store proprietor, and notary. Built in 1926, this brick two-story, four-square commercial building was also used as a Masonic lodge. Years before, this site witnessed meetings of the Temperance Society. The triple-bay storefront with transoms and a simple shed porch serves the community today as Richard's Cafe, which offers Cajun-themed cuisine and live music. (Courtesy of Whites Creek Historical Society.)

One

A NEW FRONTIER

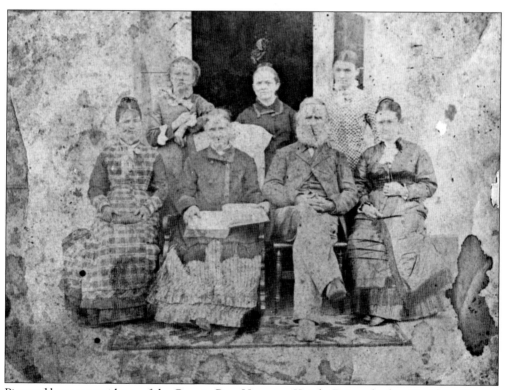

Pictured here are residents of the County Poor House on Knight Drive, the first Davidson County institution for the aged, infirm, and mentally ill, which operated from 1864 to 1879 on the farm of Thomas Harris. (Courtesy of the Marie Hudson estate.)

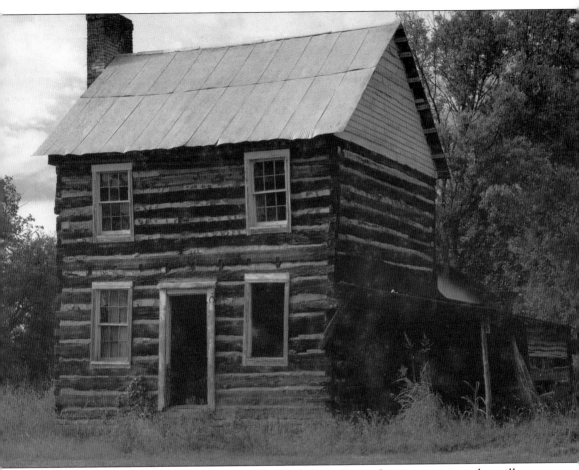

Frederick Stump (1724–1820), founder of Fredericksburg, Pennsylvania, constructed a mill on Whites Creek, and by 1789, two houses had been built nearby. Each house was built of cedar logs, and the larger of the two, which was used as a tavern, was probably the main dwelling of the Stump family. The smaller structure, which may have been a secondary residence of the family, was built on a rise overlooking the creek. This home, built in 1797, is said to be the oldest standing log house in Davidson County. It is made in the German style, featuring full dovetail notching commonly found throughout Pennsylvania, but at this time, it was almost unknown on the Cumberland. Stump was a member of the founding settlers of Nashville, alongside James Robertson and company. After Stump's death, this house became the property of William B. Ewing. (Courtesy of Paul Clements.)

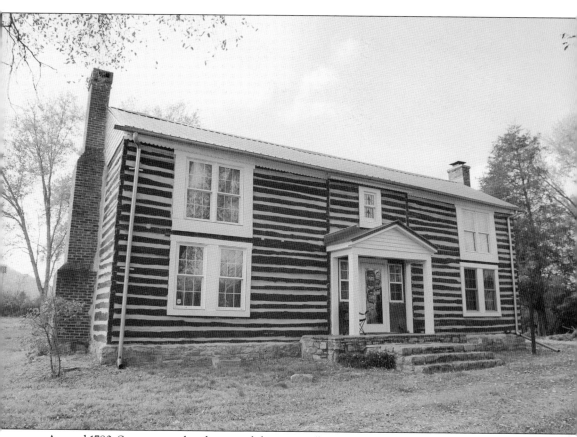

Around 1780, Stump owned and operated this tavern (located at 4949 Buena Vista Pike), a distillery, an inn, and 2,400 acres of land. In 1816, at age 93, he married one of the barmaids at the tavern, Catherine Gingery, who was 27 at the time. For the last years of his life, the tavern was leased, and Stump lived with his young wife on what was known as Dry Fork of Whites Creek. When Stump died in the spring of 1820 at the age of 97, his estate was divided among his heirs, with Catherine receiving the Dry Fork home and 300 acres of land. Catherine successfully went on to run the farm, living into the 1880s. She was most notably known to assist her extensive family, cooking for as many as 200 guests, and for her ability to make high-quality handkerchiefs from silk that had come from her garden. (Courtesy of Whites Creek Historical Society.)

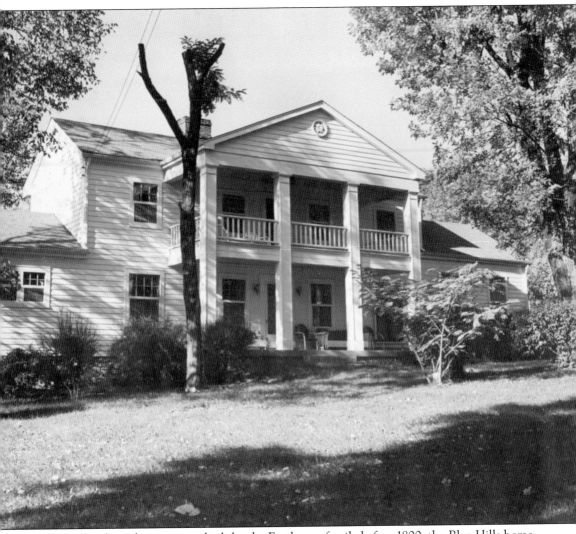

Originally a log cabin structure built by the Earthman family before 1800, the Blue Hills home (4700 Whites Creek Pike) was built in 1836 by W.S. Whiteman, with the paper mill added in 1849. The Earthman family has a long history in Whites Creek, with several notable residents including John H. Earthman, who served as captain of Company G, a part of Bates Second Army of Tennessee during the Civil War. He and his troop quickly headed to Virginia upon notification, and immediately joined the battle at Lynchburg in 1861. They were the first Tennessee troops to engage in the war. (Courtesy of Jeremy Stephens.)

STATE OF TENNESSEE

DEPARTMENT OF AGRICULTURE

Mrs. Ernest Williams

As required by Senate Bill 304, Chapter 34, of the Acts of the General Assembly of 1925 I have this day registered

Blue Hills

as the name of your farm located in *Davidson* County of Tennessee

Homer Hancock

Commissioner of Agriculture

Date *August 10, 1926*

During the Civil War, the stone mill located next to the home at Blue Hills created some of the highest quality paper available in the area, due to the rich mineral content of the creek water. Businessman W.S. Whiteman built the paper mill in 1849 and used cloth rags, rather than wood pulp, in making the paper. Whiteman kept personal addresses in both Nashville and at the house on the mill property, which continued in operation as a mill until Nashville was captured by the Union. Whiteman also owned and operated a gunpowder mill near Manchester that supplied the Confederate government until March 1862. The mill was later reopened as a barn after Whiteman's return from the Civil War. Pictured here is a certificate dated August 1926 from the State of Tennessee Department of Agriculture presented to Mrs. Ernest Williams, confirming the farm name "Blue Hills" to one of its many owners over the years. (Courtesy of Jeremy Stephens.)

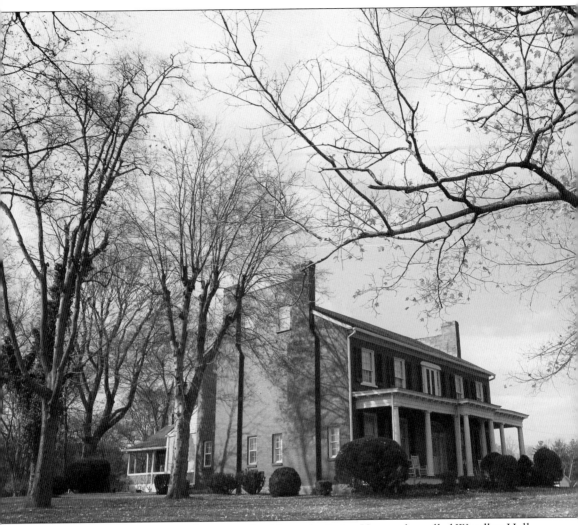

The stately Southern mansion known as the Alexander Ewing House, also called Woodlon Hall, is located about six miles north of Nashville along the west bank of Whites Creek, at 5101 Buena Vista Pike. The home, built in the Federal style, shows proof of the master architects and skilled craftsmen in the area during this time. The Alexander Ewing House was nominated for the National Register of Historic Places in 1979 and is located next door to the Stump House. Capt. Alexander Ewing lived in the Stump House while Woodlon was being built. He was given 2,666 acres in Davidson County as thanks for his Revolutionary War service. The house was completed shortly before his death in April 1822. (Courtesy of Whites Creek Historical Society.)

The Yarbrough House (3831 Whites Creek Pike) was built in the mid-1830s by a prosperous farmer, James Yarbrough, and operated as a tavern and halfway house for the stagecoach after the Whites Creek Turnpike was built in 1845. Pictured is a family reunion of James Powhatan Williams and Nannie Reid Smith Williams, who purchased the home in 1894. It was outfitted with indoor plumbing in 1949 and bought by Turner Williams, owner of Williams Grocery. (Courtesy Angela Williams.)

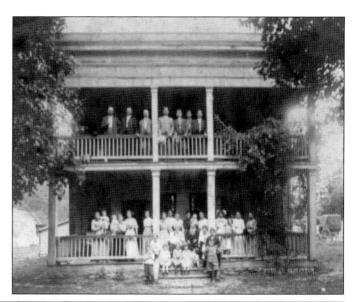

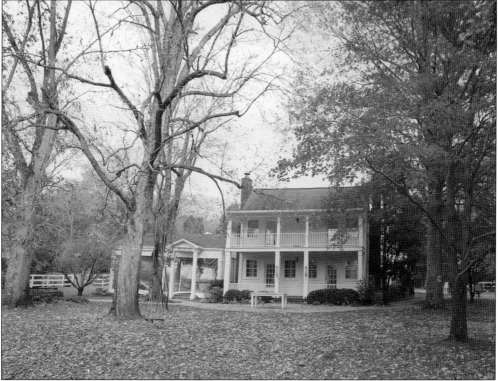

The Yarbrough House is an excellent example of a Tennessee vernacular structure. In 1820, Frederick Stump passed away and left 89 acres on the east side of Whites Creek to his grandson Tennessee Stump. Seven years later, this tract, plus seven acres purchased from Catherine Stump, became the homestead of James and Margaret Yarbrough. The house is a two-story, weatherboard, double-pen plan with each room opening onto a double gallery across the front, and was built in 1835. Today the property is known as Cedarwood and serves as a wedding and event space centered around the Yarbrough House on 50 acres. (Courtesy of Whites Creek Historical Society.)

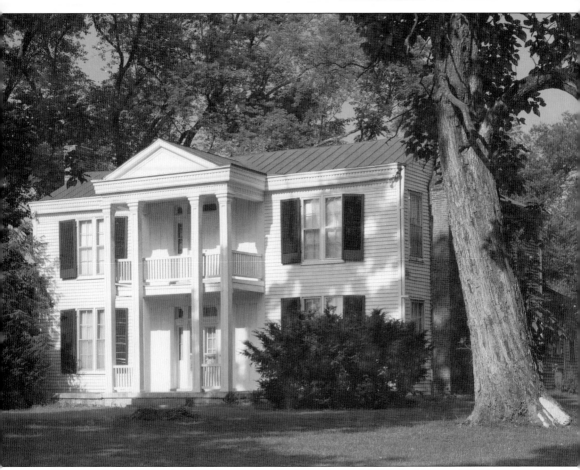

This neoclassical Greek revival house was built in the mid-1800s by Edmund P. Graves, who married a step-niece of Frederick Stump. After Frederick's death in 1820, his young widow Catherine Gingery Stump inherited a residence and 300 acres that joined Dry Fork on the south and Whites Creek on the west. Catherine shared her residence with two sisters, younger brother John, and niece Helen. In the 1850s, Catherine gave Helen a 200-acre tract where she and her husband, Edmund Graves, built this house (3832 Dry Creek Road). Graves and his wife, Helen, had six children by the time the Civil War began. With Nashville captured by the Union army in 1862, many confiscations of property occurred—but by 1870, the Graves farm had recovered a large part of its productivity. The Graveses continued to live in their house until the 1900s. J.D. Campbell owned the property from the 1920s until William H. Thompson Jr. and his wife, Jean, obtained the farm in 1950. (Courtesy of Paul Clements.)

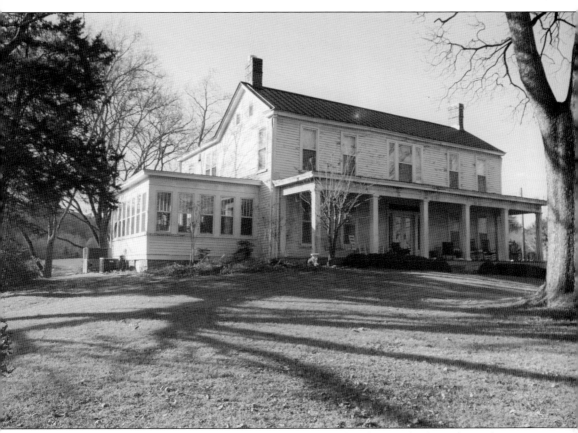

The Bysor-Thompson House, located at 4300 Whites Creek Pike, was built in the mid-1800s but first documented in 1880. John Casey acquired the property with a Revolutionary War land grant from Virginia, dated 1792. The property was sold by Samuel Casey to John Bysor, including 496.5 acres of land, on February 2, 1847, for $7,000. There is evidence of a possible dog trot–style log structure underneath the home, while the original Casey residence maintained its L-shape through the mid-1800s. The Casey family cemetery is also on the property, complete with its famous Fisk Model 1 cast-iron coffin. In 1916, wealthy German immigrants from the Neuhoff Packing Company purchased the home for $21,000. The company purchased the house, had it remodeled, and then sold it to the president of the company, Henry Neuhoff, on January 18, 1919, for $25,000. In February 1941, the house was sold to William Herman Thompson and his wife, Odie, for $18,000, including 332.5 acres of land. The present structure retains much of the form of the Neuhoff period. (Courtesy of the Thompson estate.)

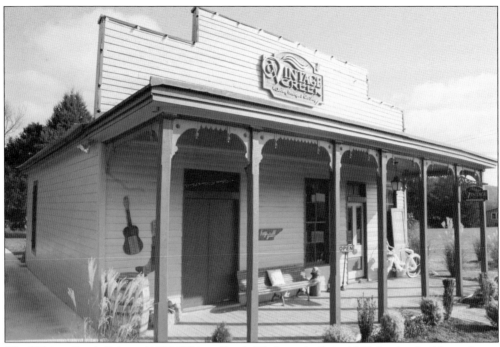

The Whites Creek Saloon (4409 Whites Creek Pike) was built in 1860. In this building, then a combination saloon and grocery, W.W. Earthman, magistrate and ex-constable of Davidson County, arrested Bill Ryan, alias Tom Hill, a ruthless and indiscreet member of the James Gang, after he drew a pistol in the saloon on March 25, 1881. He was soon charged with murder in Georgia and robbery in Alabama. Several members of the gang were living in the Edgefield neighborhood at the time. Frank and Jesse James and their families left the Nashville area the next day. (Courtesy of Whites Creek Historical Society.)

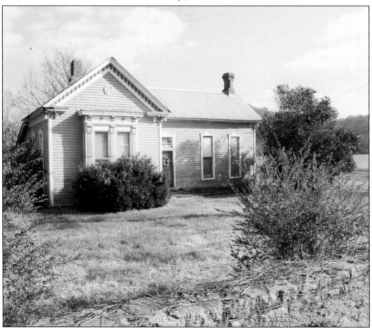

The Earthman home (4401 Whites Creek Pike) is located across the street from the Whites Creek Post Office and was built around 1882. With his reward money from the Ryan arrest, Earthman built a three-room addition to his shotgun-style home. Years later, the property was rented by Ketch Secor of Old Crow Medicine Show during the band's early days in Nashville. (Courtesy of Whites Creek Historical Society.)

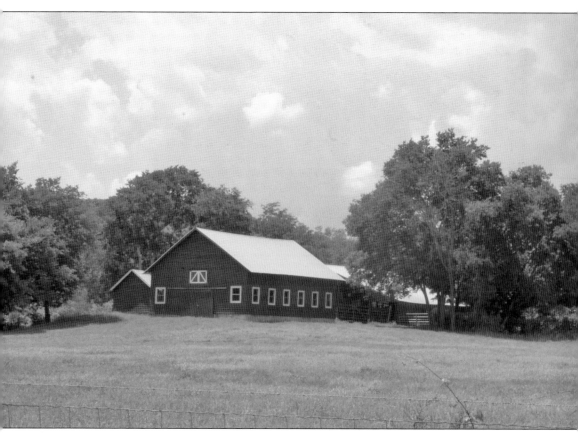

The Pleasant View farm is perched overlooking the convergence of three valleys of rich farmland. The farm has been in the Marshall family since 1787, when Gilbert Marshall sold his Revolutionary War land grant in Virginia and purchased this farm on the Tennessee frontier, where his son was soon killed by Indians. The 95-year-old dairy barn and milk house were restored in 2009 by the Williams family. (Courtesy of Angela Williams.)

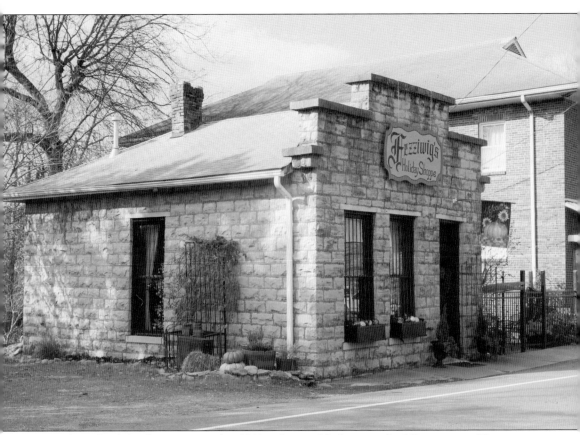

Whites Creek Bank was organized in 1911 and opened for business the following year. The organizers were chief executive officer M.P. Lesuier, Charley Bidwell, Dr. M.E. Link, and R.D. Mitchell. The bank also served as the post office from 1948 to 1960. For over 50 years, it was the only bank in northwest Davidson County, an area that covers over 100 square miles. At this bank, one's credit score was a handshake. (Courtesy of Whites Creek Historical Society.)

Two

Building a Community

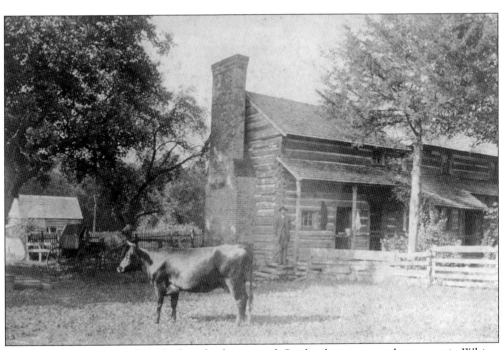

An early settler is pictured overlooking his homestead. Settlers began to put down roots in Whites Creek, building a community. (Courtesy of the Hudson estate.)

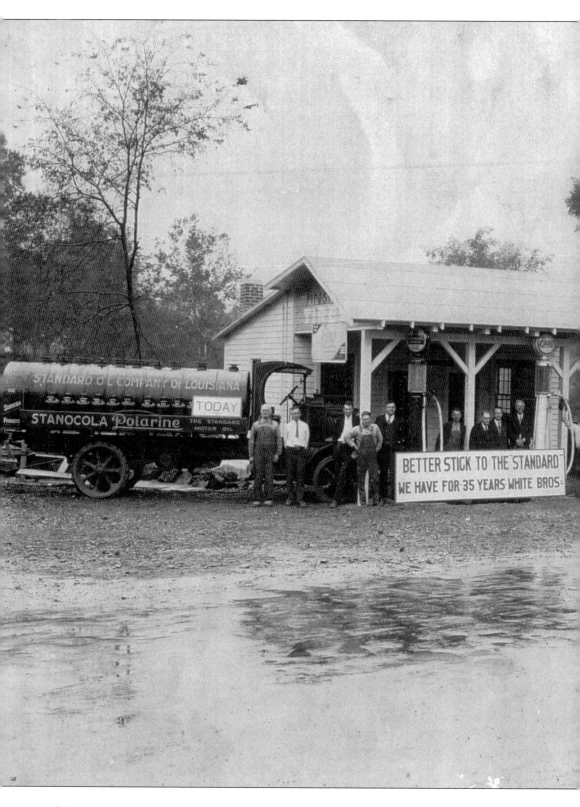

Standard Oil Company of Louisiana was a subsidiary of Standard Oil of New Jersey and operated under that name starting in 1909, and was known as Stanocola until 1924. The sign in front of the White Brothers Standard Esso station dates this photograph to between 1905 and 1917. (Courtesy of Whites Creek Historical Society.)

FALL, 1888. **SPRING, 1889.**

Wholesale Trade Price List of Strawberry Plants,

—GROWN AND FOR SALE BY—

J. B. CARNEY, NASHVILLE, TENN.

This list is intended for Nurserymen and dealers only, and contains only such kinds as I grow in large quantities. For prices on "new varieties" and others not mentioned here, see Wholesale Price List No. 2, from which a discount of 10 per cent. will be allowed to the Trade.

☞SPECIAL NOTICE☜

I grow plants by the acre to dig and sell, and make a specialty of supplying the wholesale trade, and believe I have made prices as low, quality of plants and manner of packing considered, as plants can be grown and packed.

I have had sufficient experience in packing plants for shipment to learn among other things exactly what a strawberry plant requires, in order that it may arrive at its destination in proper condition.

Nurserymen at a distance ordering plants of me by express, for filling their orders, can depend on getting them in just as fresh and live condition as if dug from their own grounds, with the care plants usually receive after being dug.

In digging plants I take the bed up solid; in this way all the strongest best plants are taken up, the small and worthless ones being discarded. Customers cannot fail to see that by this method a much better grade of plants will be obtained than where dug from between rows of bearing beds, (as is usually done to make alleys for picking), where only small and weak plants—the last efforts of the runners—are obtained.

Like all other establishments of this kind I sometimes run out of some particular variety. In such cases I reserve the right to substitute others of equal value.

Remittances may be made by any of the safe methods usually employed.

Terms:—Where satisfactory reference can be given and to prompt paying customers of previous seasons I will allow a time of 30, 60, or 90 days if desired. To all others strictly cash. No plants sent C. O. D. unless at least one-third of purchase money be sent as a guarantee of good faith. Address,

J. B. CARNEY.

—REFERENCES—

A. W. Newsom, Proprietor Rosebank Nurseries, Nashville, Tenn., J. I. Newsom, Proprietor Grand Central Nurseries, Nashville, Tenn., Fourth National Bank, Nashville, Tenn.

PRICE LIST OF PLANTS

	PER 100	PER 1,000	PER 10,000		PER 100	PER 1,000	PER 10,000
Crystal City	.30	$2.00	$15.00	Manchester	.30	$2.25	$20.00
Chas. Downing	.30	2.00	17.50	Parry	.30	2.25	20.00
Crescent	.30	2.00	17.50	Sharpless	.30	2.00	17.50
Cumberland	.30	2.25	20.00	Indiana	.30	2.00	17.50
				Jumbo	.30	2.25	20.00
Glendale	.30	2.25	20.00	Piper's Seedling	.30	2.00	17.50
Kentucky	.30	2.00	17.50	Windsor Chief	.30	2.25	20.00

All plants will be nicely straightened, tied in bundles of 25 and packed in crates in such a manner as to be as fresh after a 2 or 3 days ride as when they started. Prices quoted are for the quantities specified, but 50, 500 and 5,000 will be sent at 100, 1,000 and 10,000 rates respectively. While I believe the above figures to be as low or lower than can be obtained from any other responsible grower for strictly first class plants, yet on an order for 50,000 at one time, to be delivered as needed through the fall months, I will allow a discount of 10 per cent. For an order of 100,000 all to be delivered within 60 days of date of order, a discount of 20 per cent. will be allowed.

☞SPECIAL NOTICE☜

My personal attention will be given to all packing and shipping, and I beg to assure my customers that no pains will be spared to avoid all mistakes and to give entire satisfaction. If any errors should occur, notice should be given at once and they will be cheerfully rectified.

J. B. CARNEY,
NASHVILLE, TENN.

Oakland Fruit Farm was owned and operated by Elijah McHenry Carney and his son James Buchanan Carney. The farm encompassed all the bottomland from beyond Elijah's home (at 4398 Stenberg Road) all the way to Dry Fork Road. They published a catalog listing varieties of fruit trees, bushes, and plants. The farm tapped maple trees on Elijah's land in an area called Sugar Camp Hollow off Carney Creek, selling the maple syrup locally and by mail. (Courtesy of the Carney estate.)

This is a burial receipt from undertaker and deputy coroner Theo Kramer, dated February 2, 1893. (Courtesy of the Carney estate.)

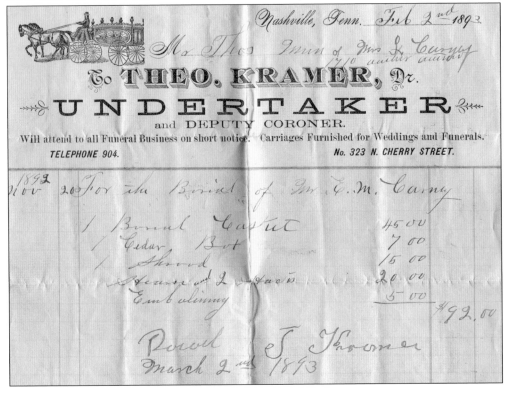

Pictured is a deed to the Oakland Fruit Farm owned by James Buchanan Carney, dated September 2, 1886. (Courtesy of the Carney estate.)

STATE OF TENNESSEE, Register's Office, _Sept 2nd 1886_
DAVIDSON COUNTY.

I, *THOS. LUSTY*, Deputy Register for said County, do certify that the foregoing Instrument and Certificate are registered in said Office, in Book No. _96_ Page _145_, that they were received _Sept 1st 1886._ _B_ at _12_ o'clock — M., and were entered in Note Book 9, Page _90_

Thos. Lusty
Deputy Register Davidson County.

Commissioner's Office,

Nashville, Tenn, February 25 1864.

I do hereby Certify, That on the _25_ day of _February_ 1864, at _Nashville Davidson County Tenn_, the oath prescribed by the President of the United States, in his Proclamation of _December 8, 1863_, was duly taken, subscribed, and made matter of record by _D. H._ _Bailey_ of _Davidson_ County. The same being No. _419_, of the book of said County.

E. Campbell
Commissioner.

Dated February 23, 1864, this certificate states that D.H. Bailey of Nashville swore an oath on that date related to Pres. Abraham Lincoln's December 1863 Proclamation of Amnesty and Reconstruction. (Courtesy of the Carney estate.)

The Johnson Farm, built in the 1880s, is the current location for Whites Creek Historical Society meetings. Owners Lynn and Judy Johnson bought the dairy farm from the Teasley family in the 1980s, which was originally part of Pleasant View Farm. Lynn Johnson was born in the stone farmhouse that currently serves as a gift shop for Fontanel. The Johnsons maintain the oldest dairy herd in the state of Tennessee. The farm lies on the banks of Whites Creek and is also home to the Marshall Mounds—dating back 5,000 years to the Mississippian era and the Stone Box Indians. (Courtesy of Whites Creek Historical Society.)

Kitty Connell Cartwright, a frequent guest of Pleasant View Farm, at 7203 Old Hickory Boulevard, is featured in this portrait. (Courtesy of Angela Williams.)

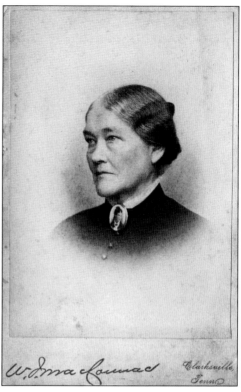

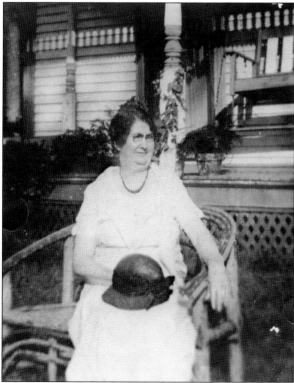

Lily Marshall Connell is seated on the front porch of her 1850s home at Pleasant View Farm. (Courtesy of Angela Williams.)

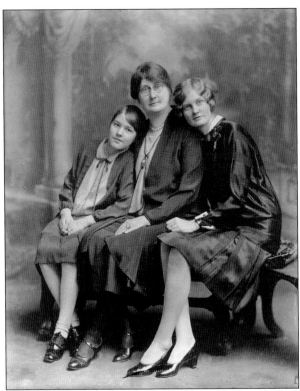

This is a 1920s photograph of, from left to right, Ella Phillips Connell, Lily Marshall Connell, and Martha Connell. (Courtesy of Angela Williams.)

Pictured here are Ella Phillips Connell Williams (left) and her cousin Eleanor Connell Witter. (Courtesy of Angela Williams.)

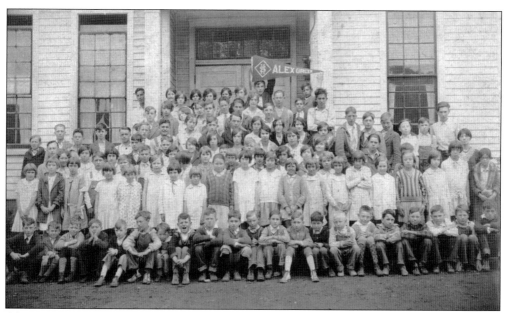

Alex Green was a well-known Methodist minister who owned a farm on Whites Creek Pike. Both the school (pictured here) and a church were named for him. His daughter Julia Green was primary school supervisor in Davidson County for over a quarter of a century. (Courtesy of Angela Williams.)

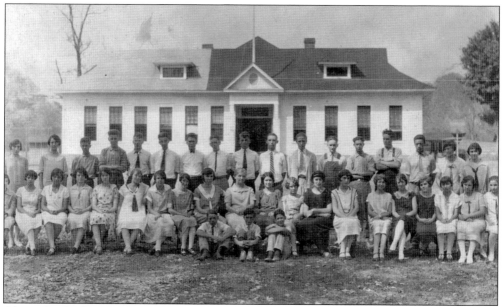

Alexander Little Page Green (1806–1874) joined the Methodist Episcopal Church's Nashville Conference in 1829. He was elected vice president of the Tennessee Conference's Temperance Society in 1835. Green was instrumental in the Southern Methodist Publishing House's move to Nashville in 1854, and also helped establish Shelby Medical College (1857) and Vanderbilt University (1875). By private venture, he opened Union Street from College Street to Market Street in 1870. Whites Creek's first school was renamed Alex Green Academy in 1887. Pictured here are students in 1925. (Courtesy of Angela Williams.)

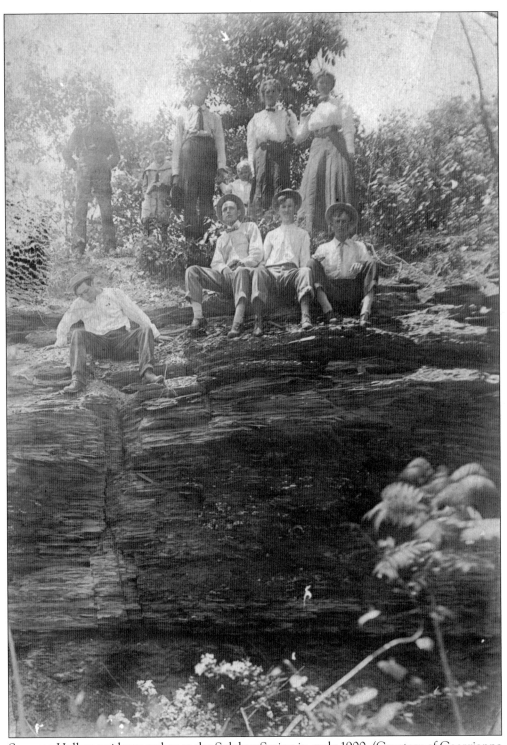

Seymore Hollow residents gather at the Sulphur Spring in early 1900. (Courtesy of Georgianna Burton Johnson.)

James Riley Burton, born December 12, 1869, married sisters and claimed to have invented the turnip green cutter. (Courtesy of Georgianna Burton Johnson.)

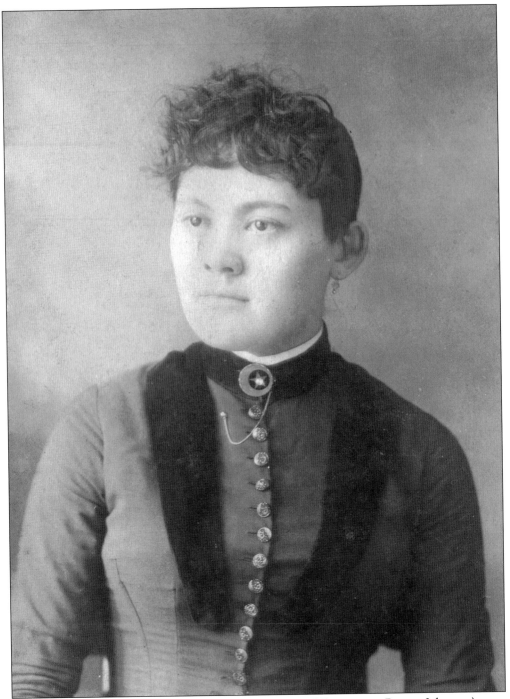

Sarah Ann Barnes was born on May 21, 1867. (Courtesy of Georgianna Burton Johnson.)

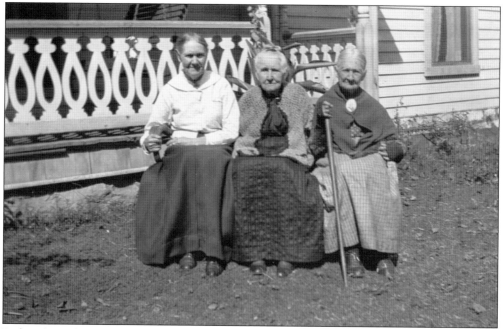

Ladies from the Duke family pose for a photograph outside their Whites Creek homestead. (Courtesy of the Hudson estate.)

Donald Reed Hudson, pictured here, was born in 1924. (Courtesy of the Hudson estate.)

Elise A. Harlan Jones is featured in this graduation picture from 1920. (Courtesy of the Hudson estate.)

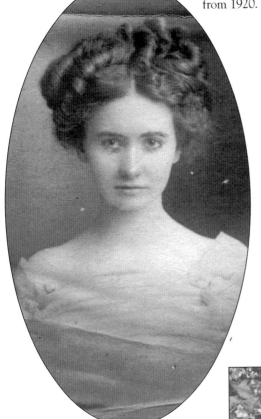

The Frierson sisters—from left to right, Nellie, Ardie, and Irene—were an inseparable trio known throughout the blossoming community. (Courtesy of the Hudson estate.)

James Pickard is featured alongside classmates at the Ewing School. (Courtesy of the Hudson estate.)

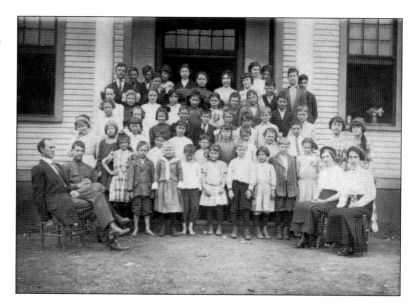

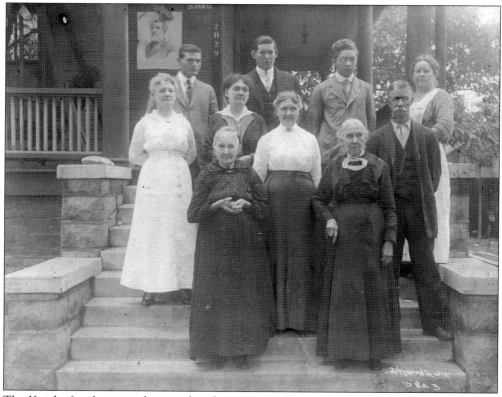

The Knight family is seen here at their home site on Knight Road. Identified are Newton Lee Knight Sr. (top right with glasses), Leila Harris Evans (in the white dress), and Mammy Knight (right of Evans). (Courtesy of the Hudson estate.)

Maisie Jones graduated high school in 1922. She is seen here in a school photograph. (Courtesy of the Hudson estate.)

Seen here from left to right are Marie Jones Hudson (holding James Frierson Hudson), Wesley Gaines Jones (in back), Manella Elizabeth Jones Marable, and William Jones. (Courtesy of the Hudson estate.)

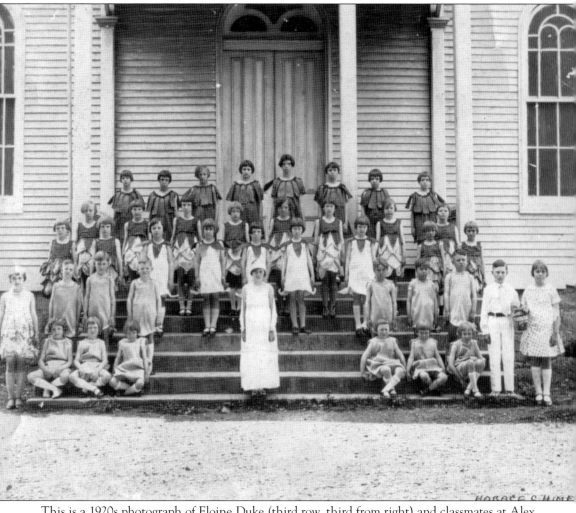

This is a 1920s photograph of Eloine Duke (third row, third from right) and classmates at Alex Green School. (Courtesy of the Hudson estate.)

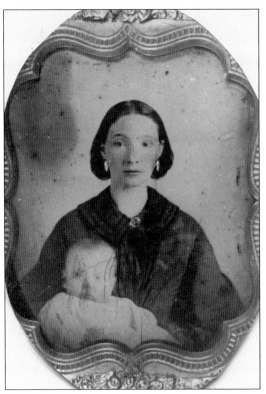

America Lou Casebear, a Native American born in 1817, married John Capps in 1833. She is the great-grandmother of Searcy Neldt Capps. (Courtesy of Sandra Capps Reinhardt.)

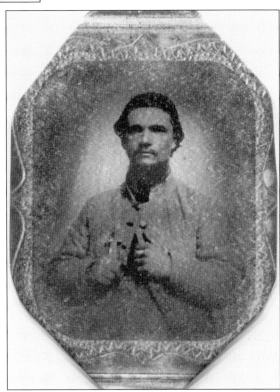

Ephraim Capps, son of America and John Capps, joined the Confederate army when he was 16 and drove an ambulance during the war. (Courtesy of Sandra Capps Reinhardt.)

Brothers Albert (left) and Harvey Capps are pictured here in 1925. (Courtesy of Sandra Capps Reinhardt.)

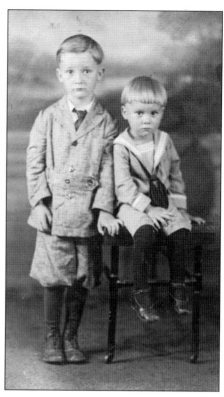

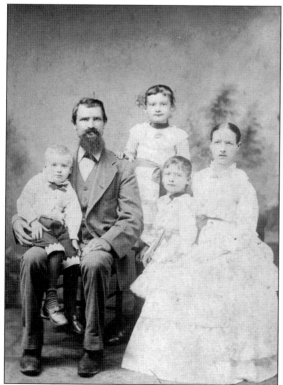

From left to right are Carl Gustav Stenberg, father Gustav Nilsson Stenberg, Alexandra Stenberg, Signe Emelia, and mother Emelia Augusta Stenberg posing for a picture once they all had arrived from Horn, Westervik, Sweden. After moving to Whites Creek in 1895, Gustav Nilsson Stenberg, a stone mason, was hired to erect the statue of Mercury on top of Union Station in Nashville. (Courtesy of the Stenberg estate.)

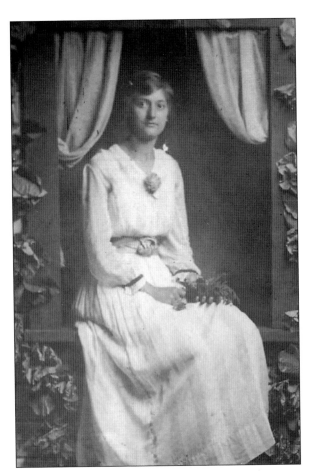

This is a 1919 wedding photograph of Selma Stenberg Capps. (Courtesy of Sandra Capps Reinhardt.)

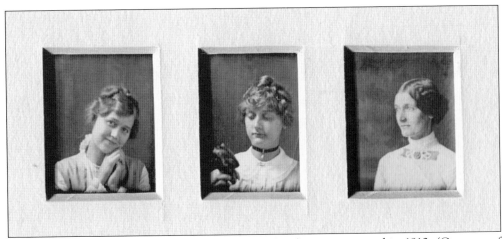

From left to right, sisters Sadie, Selma, and Signe Stenberg are pictured in 1912. (Courtesy of Sandra Capps Reinhardt.)

Searcy Capps is pictured in downtown Nashville. (Courtesy of Sandra Capps Reinhardt.)

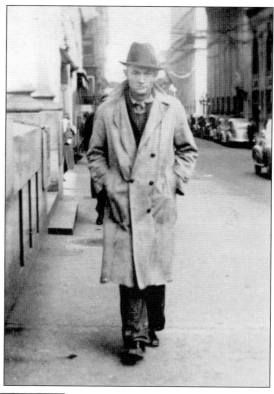

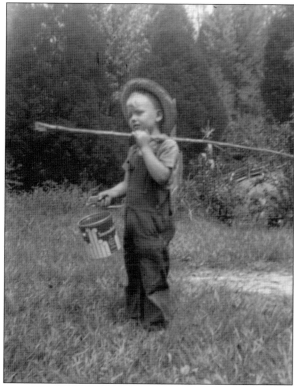

Sven Capps is pictured fishing in 1939. (Courtesy of Sandra Capps Reinhardt.)

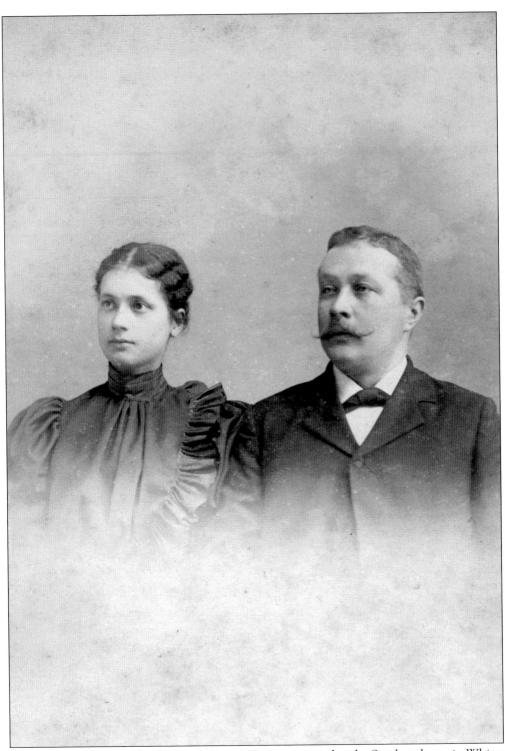

Alexandra Stenberg and her husband, August Kastner, married at the Stenberg home in Whites Creek on November 22, 1897. (Courtesy of Marsha Stenberg Murphy.)

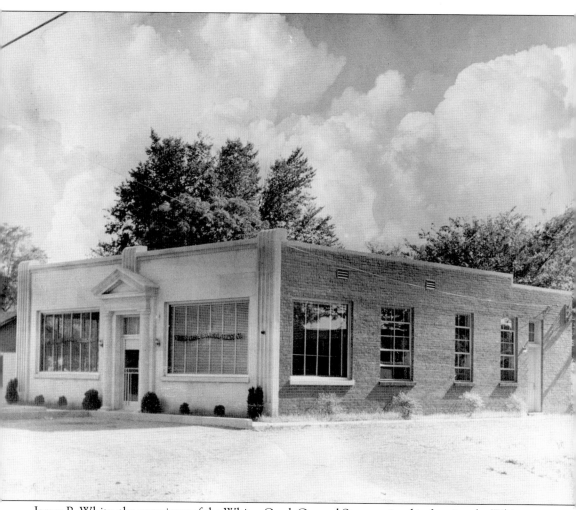

James B. White, the proprietor of the Whites Creek General Store, assisted in forming the Whites Creek Bank and Trust Company in 1911. (Courtesy of Whites Creek Historical Society.)

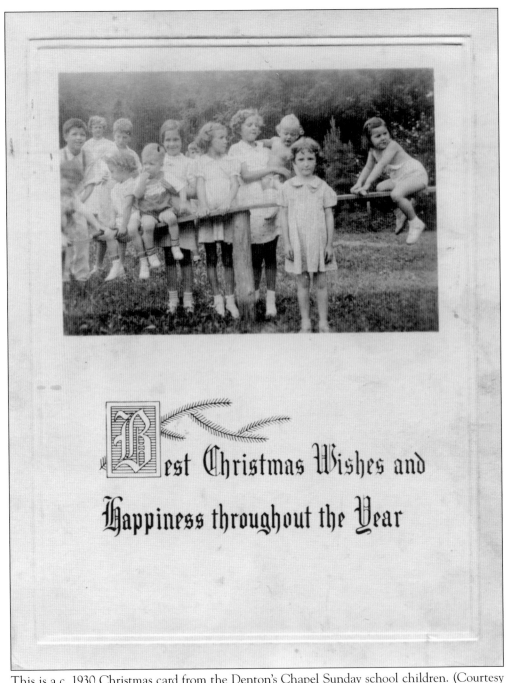

Best Christmas Wishes and Happiness throughout the Year

This is a c. 1930 Christmas card from the Denton's Chapel Sunday school children. (Courtesy of Whites Creek Historical Society.)

Three

MOVING TOWARD
MODERNIZATION

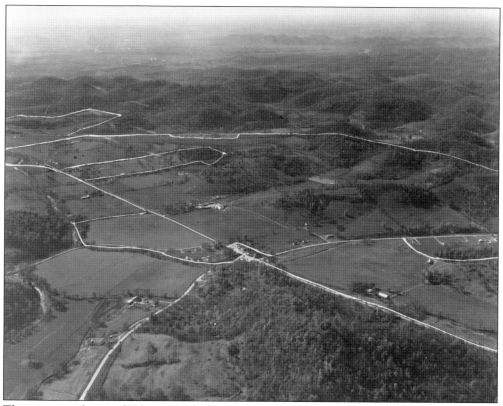

This is an aerial view of Whites Creek, showing parcels of property lines as the community takes a step toward modernization. (Courtesy of the Thompson estate.)

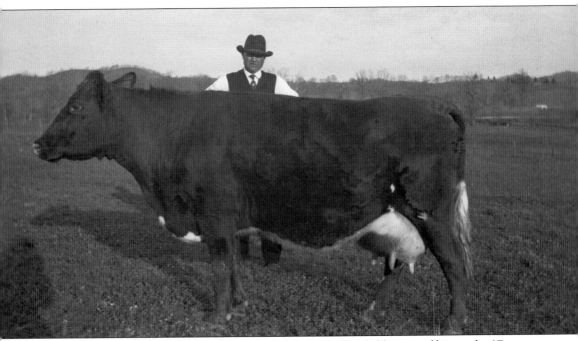

Church Duke, well known for breeding cows, is almost dwarfed by one of his cattle. (Courtesy of the Hudson estate.)

Members of the Shannon family, pictured here in 1944, worked at Country Maid Dairy and lived in a separate house on the 4300 Whites Creek Pike property. They were treated like family and became an integral part of operations at the dairy. The barn seen in the background is still intact and in use. (Courtesy of the Thompson estate.)

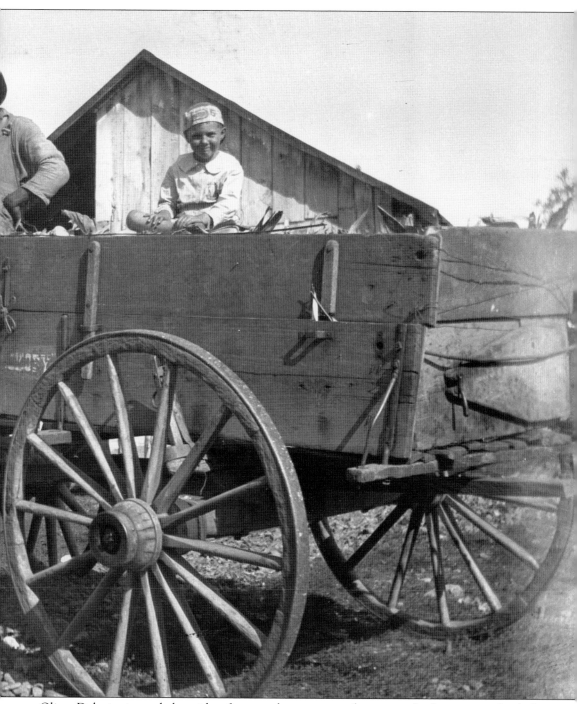

Oliver Duke is pictured alongside a farm employee on top of a wagon after harvesting a load of corn in 1916. (Courtesy of the Hudson estate.)

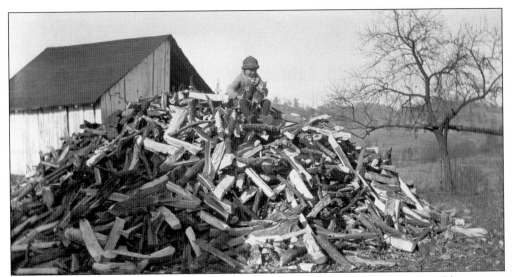

A typical day in 1914 for young Oliver Duke included playing on a woodpile. (Courtesy of the Hudson estate.)

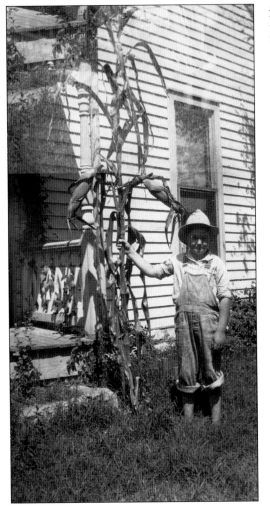

Oliver Duke proudly stands with a giant sugar cane grown on the Duke property. (Courtesy of the Hudson estate.)

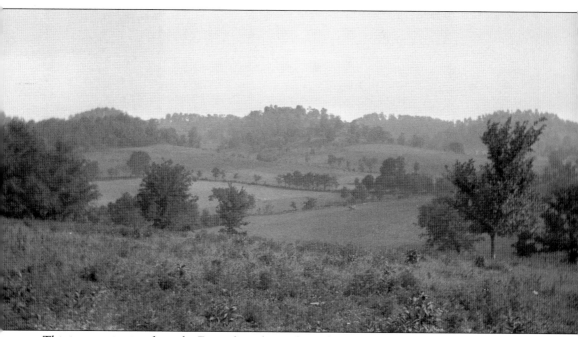

This is a scenic view from the Evans farm, located on what is now Brick Church Lane. (Courtesy of the Hudson estate.)

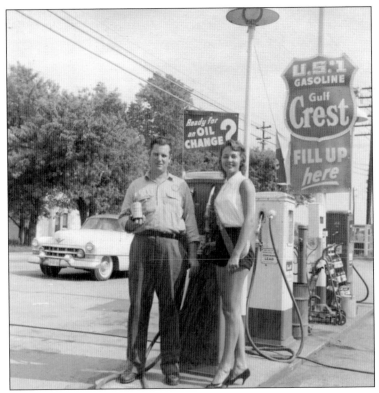

Charles Gupton Sr. and a local debutante celebrate a promotional day at Gupton's Gulf service station. (Courtesy of the Gupton estate.)

Promotional days were common at gas stations across the country as competition began to build among stations. (Courtesy of the Gupton estate.)

Charles Gupton Sr. is pictured here in the mid-1940s. (Courtesy of the Gupton estate.)

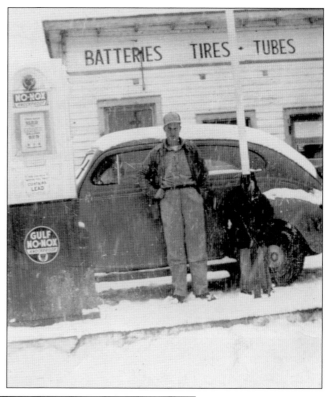

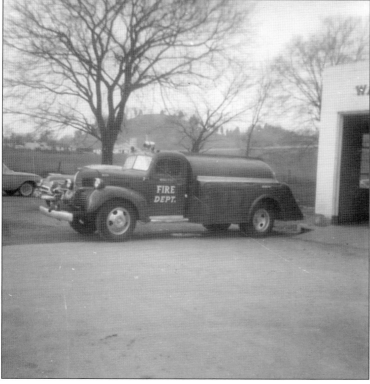

The first fire engine in Whites Creek was housed at Gupton's Gulf station and was often driven by Joe Berry or Charles Gupton Jr. (Courtesy of the Gupton estate.)

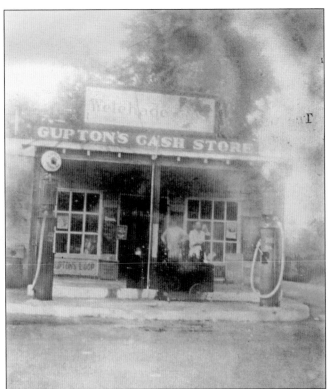

The first service station owned by Charles Gupton Sr. in the late 1940s was located on Whites Creek Pike. (Courtesy of the Gupton estate.)

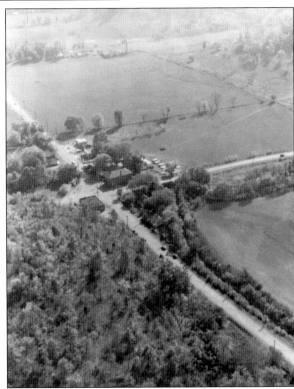

This is an aerial view of Whites Creek Pike and Old Hickory Boulevard heading southwest. (Courtesy of the Thompson estate.)

The first Methodist church in the Whites Creek–Dry Fork valley was a log structure built in pioneer days near a large spring on Dry Fork known as Ebenezer Spring. Denton's Chapel United Methodist Church claims the log structure as its mother church, tracing their congregation back to an 1885 revival at the Dry Fork Road location in Whites Creek. (Courtesy of Whites Creek Historical Society.)

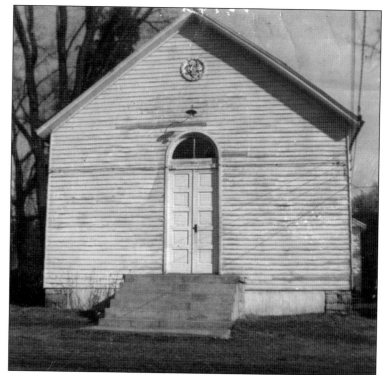

There are two churches that can claim Ebenezer for their mother church. Alex Green Church on Whites Creek Pike later moved and became St. Andrew United Methodist Church, although the building has served many uses over the years, including as a Masonic lodge. (Courtesy Whites Creek Historic Society.)

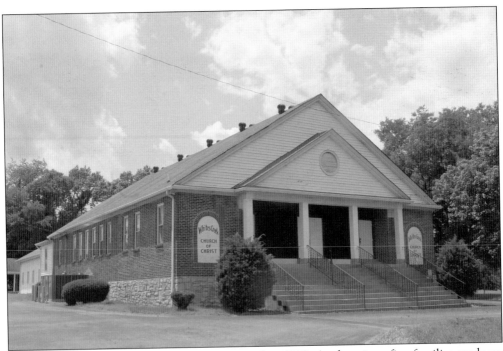

The Whites Creek Church of Christ was started in 1902. At that time, five families made up the congregation. Membership flourished throughout the midcentury, but eventually numbers decreased, and the church was closed in 2015. (Courtesy Whites Creek Historic Society.)

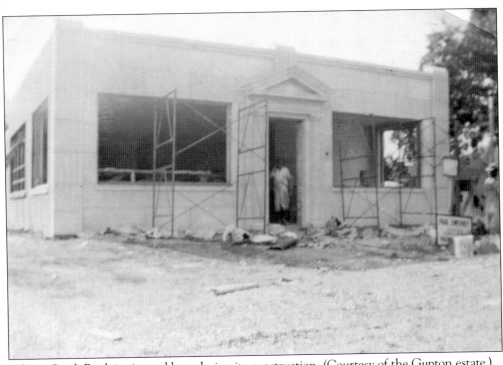

Whites Creek Bank is pictured here during its construction. (Courtesy of the Gupton estate.)

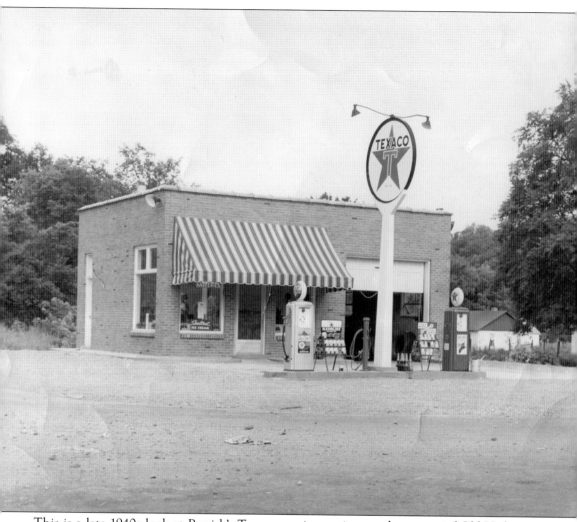

This is a late 1940s look at Parrish's Texaco service station on the corner of Old Hickory Boulevard and Whites Creek Pike. (Photograph by Jeanne Bracey Thompson, courtesy of the Thompson estate.)

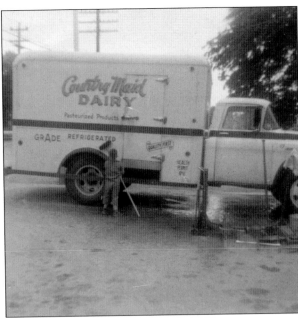

Randy Gupton, grandson of Charles Gupton Sr., is seen here washing a Country Maid truck in 1959. (Courtesy of the Gupton estate.)

Charles Gupton Sr. could often be found at the Whites Creek Fire Hall, where he helped start Whites Creek's first fire department in the 1950s. (Courtesy of the Gupton estate.)

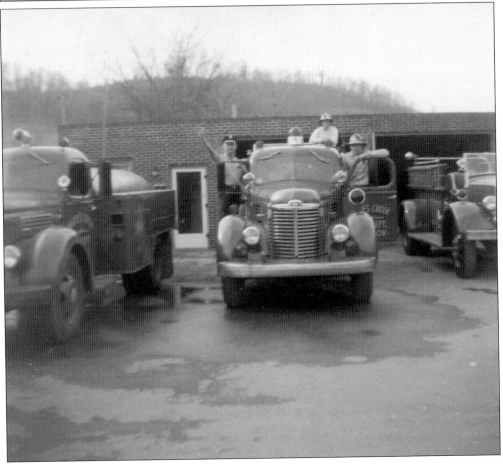

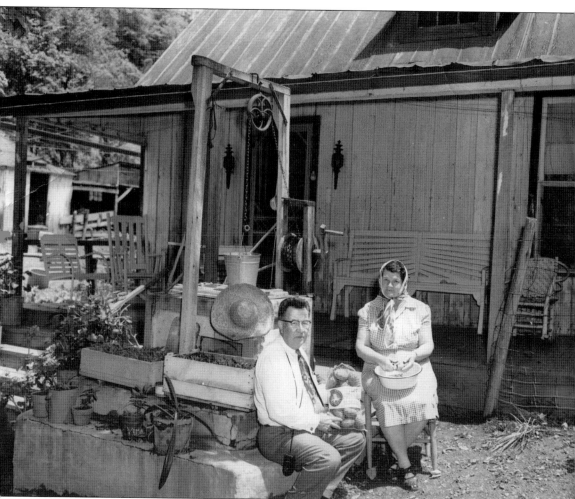

Gordon Turner, a photographer from the *Nashville Tennessean*, visits Frank and Nannie Barnes to document their fruit and berry farm on their 58th wedding anniversary in 1949. Pictured here is Turner with the Barnes' daughter Beatrice, who continued their farming tradition until her death in 1999. The Barnes farm was among the largest in Middle Tennessee from 1909 to the early 1940s. They cultivated and harvested blackberries, strawberries, raspberries, gooseberries, dewberries, grapes, plums, peaches, and apples to sell wholesale to the R.T. Overton and Sons Company, with surplus sold on the Nashville square. (Courtesy of the Barnes estate.)

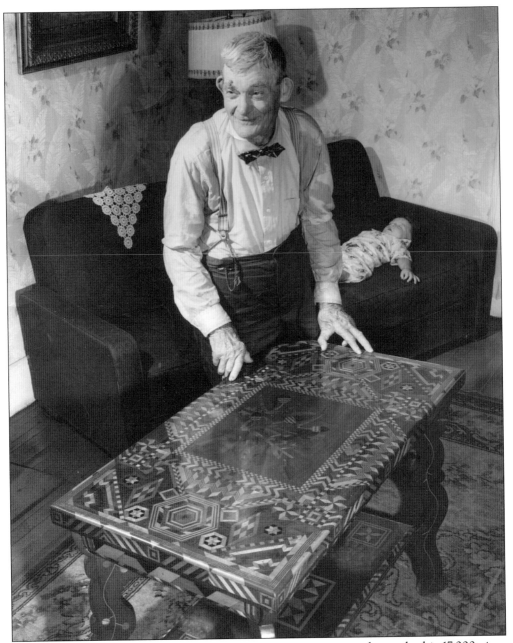

Frank Ezell Barnes, pictured here in 1949, was a master carpenter who made this 17,000-piece hand-cut inlaid table that included 100 varieties of wood from all over the world. (Courtesy of the Barnes estate.)

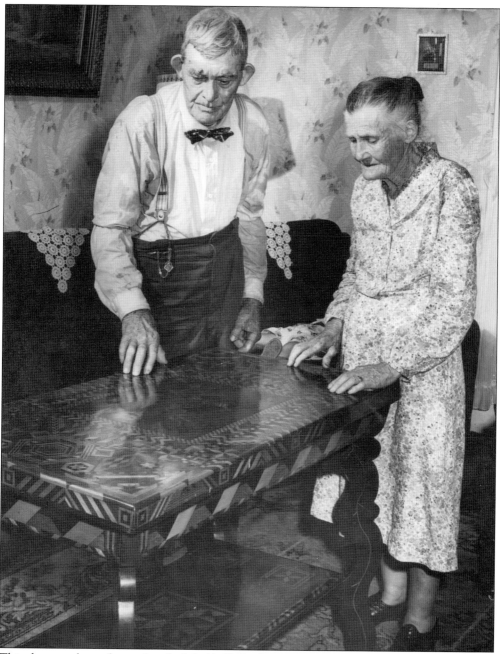

This photograph was featured in the July 13, 1949, edition of the *Nashville Tennessean*, accompanied by a full story entitled, "Fruit, Berry Farm Provides Happy Life for the Barnes." (Courtesy of the Barnes estate.)

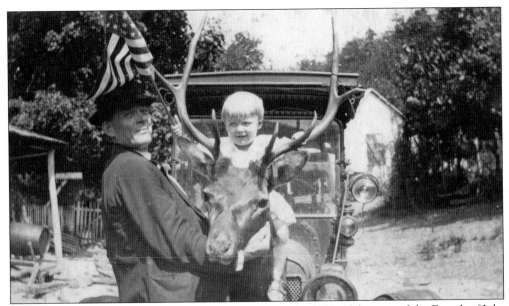

Frank Barnes holds grandson Herbert Stenberg during the 1921 celebration of the Fourth of July. (Courtesy of the Barnes estate.)

This photograph was taken during a celebration in the 1940s with family members (from left to right) Rachel MacRannolds, Lillie Stenberg, Frank Stenberg, Nan MacRannolds, Frank Barnes, and Dick Carney. (Courtesy of the Barnes estate.)

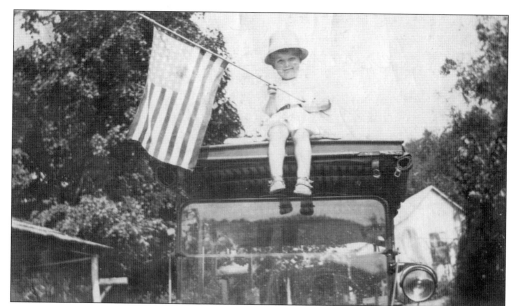

Herbert Stenberg sits on top of his grandfather Frank's Model T in 1924. (Courtesy of the Barnes estate.)

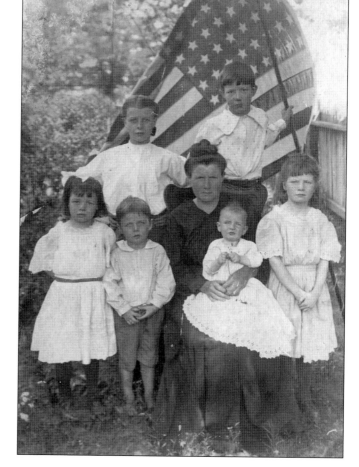

Frank and Nannie Barnes married in July 1891 and moved to Whites Creek with their six children in 1909, starting one of the biggest fruit and berry farms in Middle Tennessee. From left to right are (first row) Beatrice Barnes, Edward Barnes, Nannie Barnes (holding daughter Nancy Barnes), and Sarah Barnes; (second row) Lillie Mai Barnes and Charles Barnes. (Courtesy of the Barnes estate.)

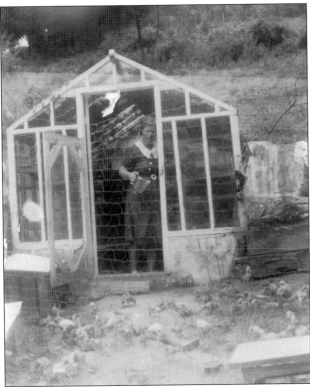

Sadie Barnes tends to her hothouse, where sweet-smelling gardenia was housed over the winter. (Courtesy of the Barnes estate.)

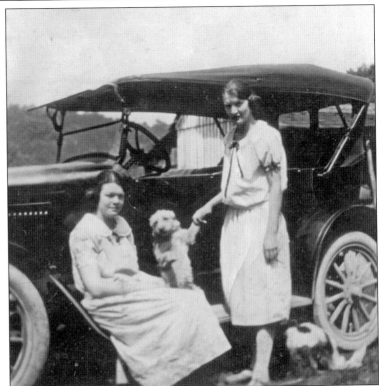

Sisters Beatrice (left) and Nan Barnes pose with their dog on the running board of a car. (Courtesy of the Barnes estate.)

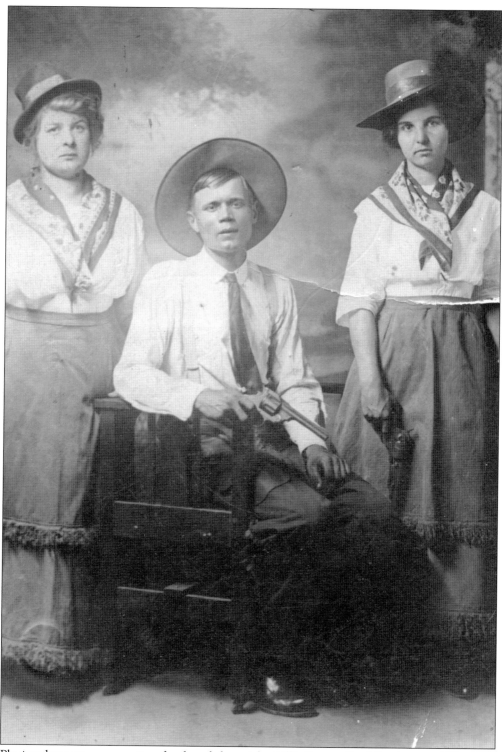

Playing dress-up was a pastime for, from left to right, Lillie Barnes, Fred Stenberg, and Elizabeth Sands in 1916. (Courtesy of the Stenberg estate.)

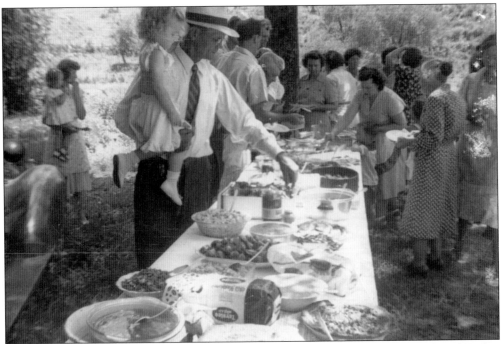

This July 4, 1942, picnic features Fred Stenberg holding Karen Stenberg on the left and Evelyn Stenberg and Nannie Maxwell Barnes on the right. (Courtesy of the Barnes estate.)

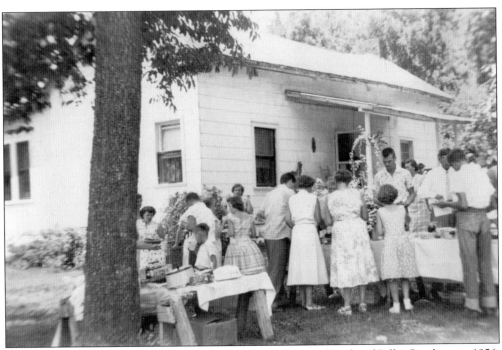

This picture was taken during a family reunion at the home of Fred and Lillie Stenberg in 1956. This was the home where Fred's parents settled in 1895 after emigrating from Sweden. (Courtesy of the Stenberg estate.)

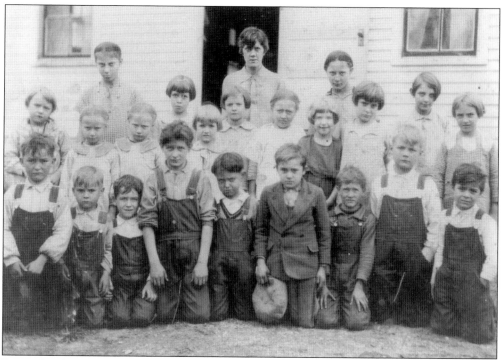

Dry Fork School students seen here in 1927 include children from the Bostelman, Burgess, Burton, Capps, Campbell, Carney, Graves, Hazelwood, Stenberg, and Vester families. (Courtesy of the Barnes estate.)

A toddler checks out the outhouse for possible wasps before entering. Also known as visiting "Mrs. Jones," this one-seater was warm in the summer and cold in the winter. (Courtesy of the Barnes estate.)

Lillie Stenberg holds her granddaughter Anna Albert on a contented cow. (Courtesy of the Barnes estate.)

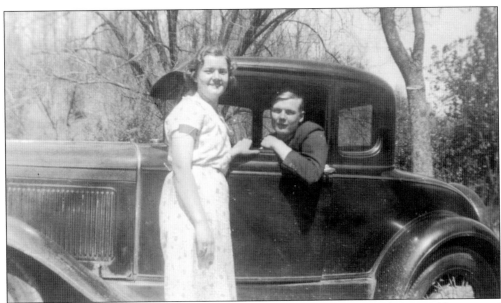

Dorothy Stenberg asks for a ride with brother Herbert Stenberg in the early 1940s. (Courtesy of the Barnes estate.)

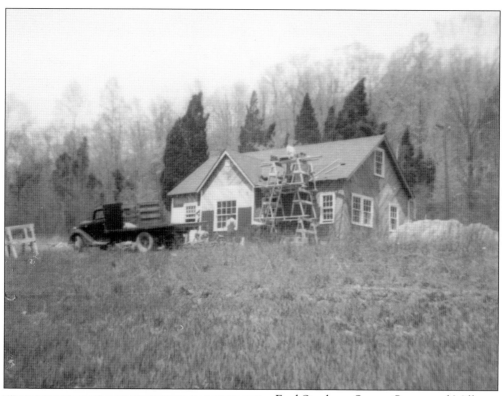

Fred Stenberg, Searcy Capps, and Miller Schurer built this home for Herbert and Evelyn Stenberg in 1952. Made from oaks harvested from their land, the walls are virtually solid wood. (Courtesy of the Stenberg estate.)

Odie Thompson was a lifelong resident of Whites Creek and served as bookkeeper for Country Maid Dairy in the 1920s and 1930s. She attended Fairview Academy and Middle Tennessee State Normal School, studying to become a teacher. (Courtesy of the Thompson estate.)

Pictured from left to right with an Overland car are Herman Thompson, Odie Thompson, E. Smith, and Luther Smith in 1918. (Courtesy of the Thompson estate.)

This school picture of Annie Eggstein was taken in the late 1920s. (Courtesy of the Stenberg estate.)

This is a family photograph of Barbara Carney. (Courtesy of the Stenberg estate.)

Frank Barnes sits in his car and poses with daughters Beatrice (left) and Lillie in 1953. (Courtesy of the Barnes estate.)

Charlie and Urlis Barnes pose with
sons Alvin (left) and Richard in 1925.
(Courtesy of the Barnes estate.)

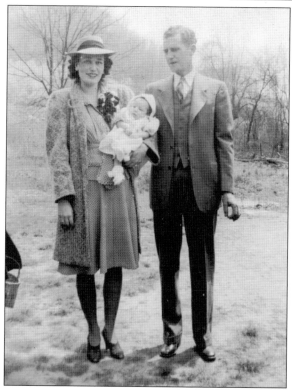

This is a family photograph
of Doris and Gene Horner.
(Courtesy of the Barnes estate.)

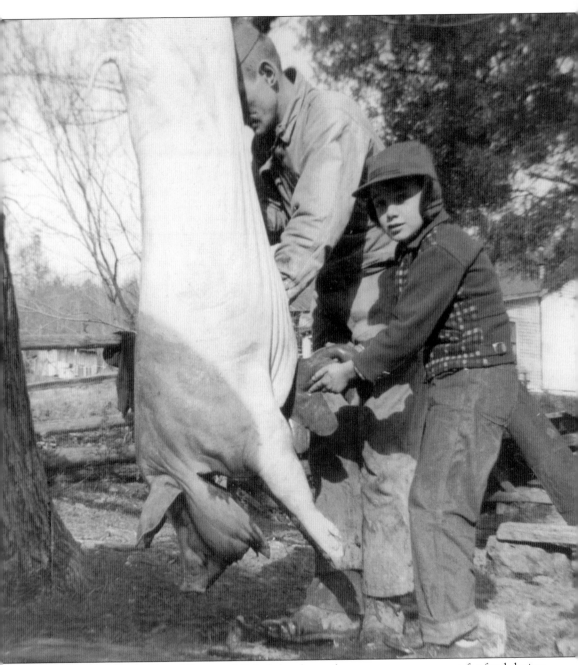

Frank Stenberg (left) and Raymond Bobel slaughter a hog, a necessary process for food during the cold winter months. (Courtesy of the Bobel estate.)

Dorothy Stenberg and Virginia
Boswell met at Nashville School
of Beauty Culture in 1938.
(Courtesy of the Bobel estate.)

Ladies from the Larkin and
Hazelwood families eat ice cream
at a church social. (Courtesy of
Whites Creek Historical Society.)

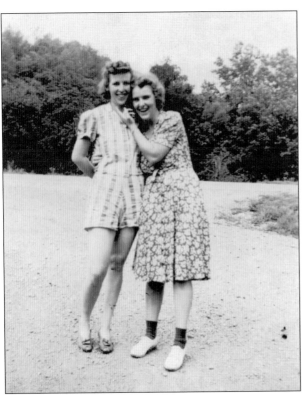

Sisters Edith (left) and Claudia Larkin pose for a photograph. (Courtesy of the Bobel estate.)

From left to right, siblings Edna, Mary, and Frank Stenberg are pictured in the side yard of the family home. (Courtesy of the Stenberg estate.)

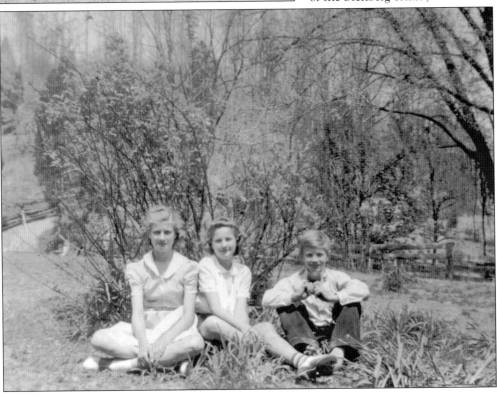

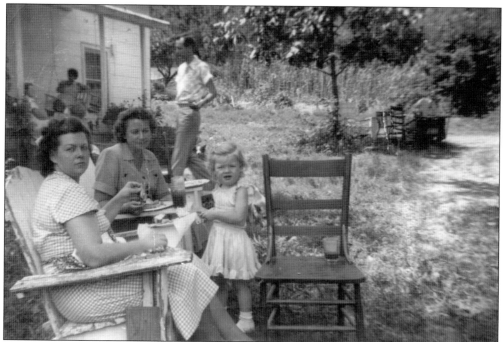

Evelyn Stenberg and daughter Karen enjoy the potluck lunch at a Fourth of July celebration in 1949. (Courtesy of the Stenberg estate.)

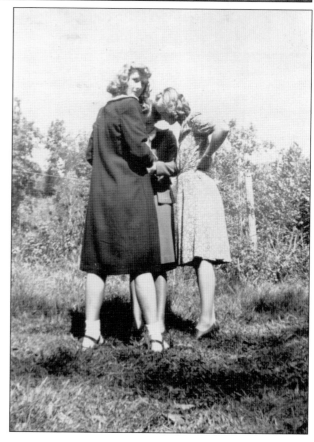

From left to right, Edna, Dorothy, and Frances Stenberg are making sure the camera will work in 1940. (Courtesy of the Stenberg estate.)

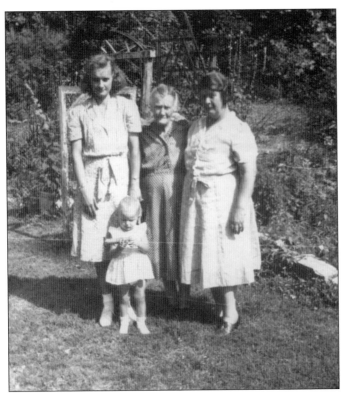

Four generations of the Barnes/Stenberg family are pictured here. From left to right are Frances Stenberg Albert, Anna Albert, Nannie Maxwell Barnes, and Lillie Barnes Stenberg. (Courtesy of the Barnes estate.)

Fred Stenberg stands beside a concrete birdbath made by his brother Carl Stenberg. (Courtesy of the Stenberg estate.)

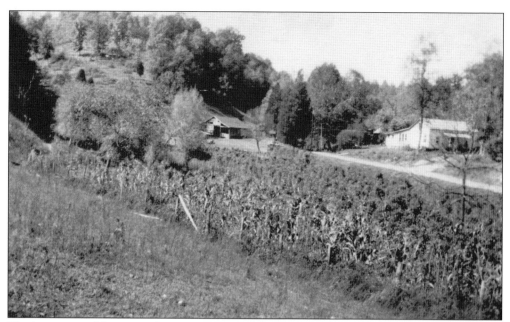

The home site of Gustav and Augusta Stenberg started as a log cabin in 1850. It was eventually purchased by son Fred Stenberg in 1941. The farm operated as a fruit and vegetable farm and dairy for over 70 years. (Courtesy of the Stenberg estate.)

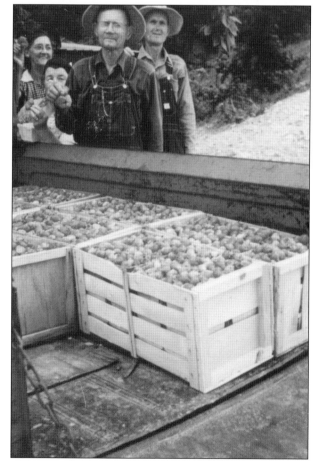

From left to right, Selma Stenberg Capps, Lillie Barnes Stenberg, George Frederick Stenberg, and Clarence Stenberg are seen here after harvesting a truckload of strawberries. (Courtesy of the Barnes estate.)

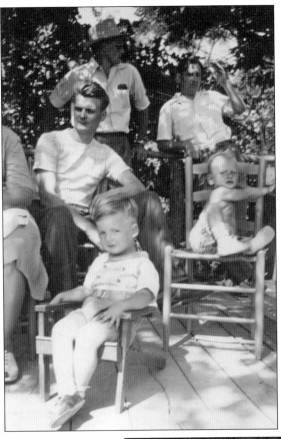

From left to right, Herb Stenberg and his son Craig, Dick Carney and his son Gene, and Larry Bobel enjoy a Sunday school picnic. (Courtesy of the Stenberg estate.)

Augusta Nilsson Stenberg is pictured here with (from left to right) Herbert Stenberg, August Eggstein, and Annie Eggstein in the early 1920s. Augusta emigrated in 1882 with her three children, all under the age of seven, to join her husband, Gustaf Nilsson Stenberg. Family descendants still live in the home site bought in Whites Creek in 1895. (Courtesy of the Stenberg estate.)

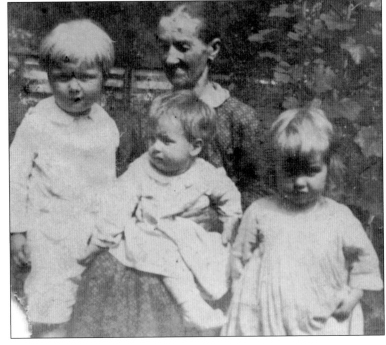

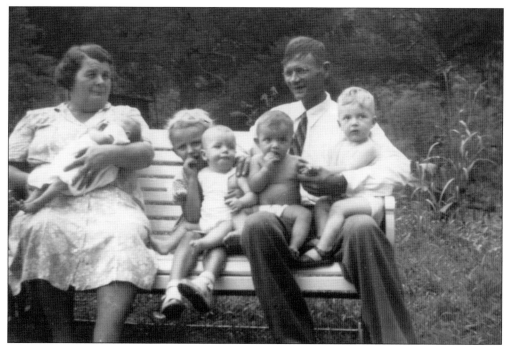

Lillie and Fred Stenberg are pictured at their home site with grandchildren (from left to right) Karen Stenberg, Anna Albert (holding Raymond Bobel), Kenneth Albert, and Craig Stenberg in 1947. (Courtesy of the Stenberg estate.)

The Stenberg farm was operated with the help of a mule team from 1895 to 1974. This mule, Red, is pastured after a long day of plowing in the 1940s. (Courtesy of the Stenberg estate.)

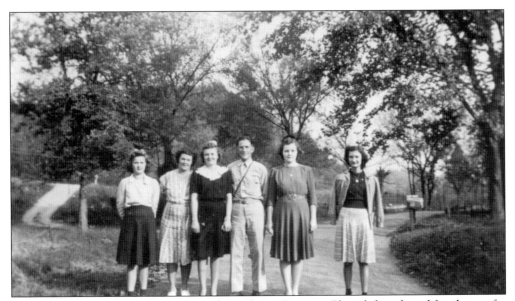

On a Sunday afternoon walk on Dry Fork Road near Dentons Chapel, friends and family stop for a quick picture. Seen here are Mary Stenberg, Beatrice Barnes, Dorothy Stenberg, Larry Bobel, Virginia Boswell, and Rachel MacRannolds. (Courtesy of the Stenberg estate.)

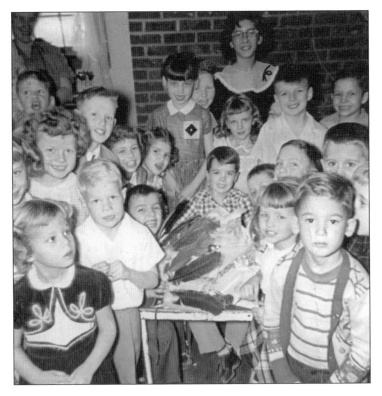

Neighborhood children surround Raymond Bobel as he celebrates his seventh birthday. Friends include Connie Chester, Karen Stenberg, John Stenberg, Randy Chester, Kenneth Albert, Linda Lish, Beverly Stanley, Dixie Graves, Martha Jo Capps, Craig Stenberg, Gene Carney, Lana Jo Graves, Frankie Burton, and Barry Capps. (Courtesy of the Bobel estate.)

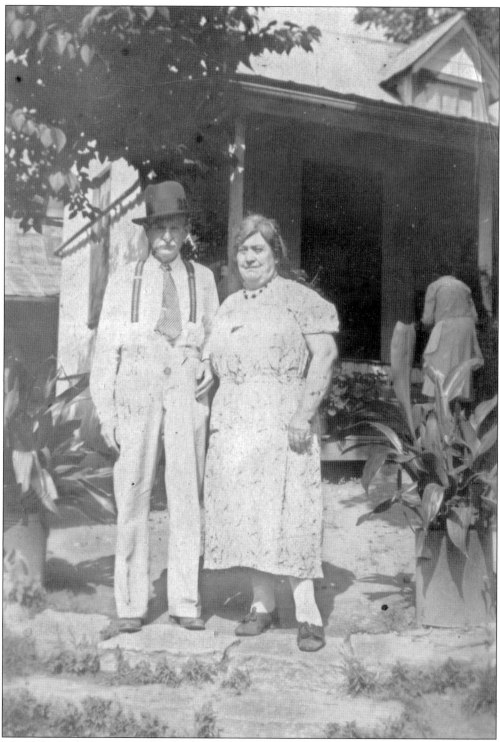

Mary Elizabeth Barnes and her husband, Polk Dallas Richardson, are pictured here in 1934. (Courtesy of the Barnes estate.)

Raymond Bobel gets to sample a cake in the making in 1950. (Courtesy of the Bobel estate.)

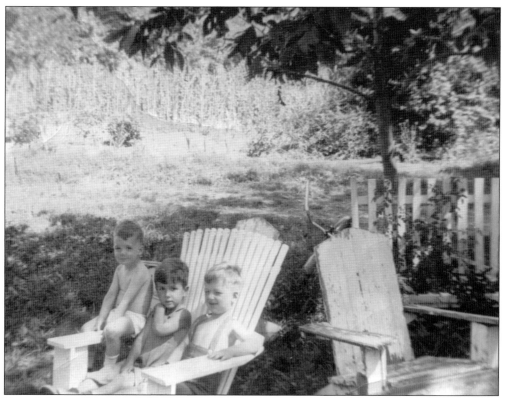

From left to right, cousins Raymond Bobel, Carl Wahlberg, and Craig Stenberg test out an Adirondack chair made by Herbert Stenberg. (Courtesy of the Stenberg estate.)

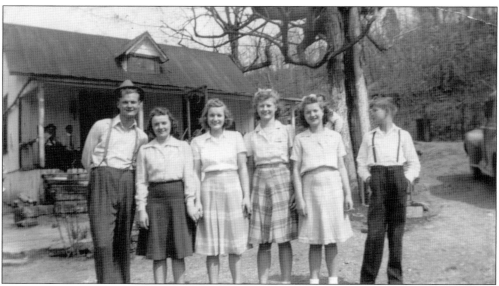

Children of Fred and Lillie Stenberg are seen in this 1940 photograph, including Herb, Dorothy, Frances, Edna, Mary, and Frank Stenberg. (Courtesy of the Stenberg estate.)

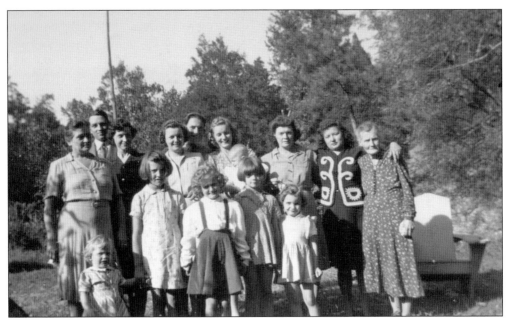

Neighbors gather for a family celebration in 1943. Among those pictured are Marguerite Carney, son Robert Bruce Carney and his wife, Sadie Mai Lanier Carney, along with Dorothy Stenberg, Larry Bobel, Frances Stenberg Albert (holding daughter Anna Elizabeth), Beatrice Barnes, Teresa Barnes, and Nannie Barnes. Children include Marie and Barbara Carney. (Courtesy of the Barnes estate.)

Oliver Duke plays outside his home, built in the mid-1800s. (Courtesy of the Hudson estate.)

Among his many crops, George Frederick Stenberg harvested truckloads of pears, which people traveled to his home to purchase. (Courtesy of the Barnes estate.)

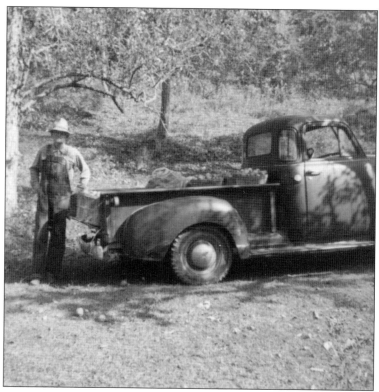

Stanley Dunn and Fred Stenberg, plowing with mules Mike and Mandy, work one of the corn crops grown to provide forage for the Stenberg farm animals in 1965. (Courtesy of the Barnes estate.)

Rock climbing on the Dry Fork Quarry are, from left to right, Beatrice Barnes, Rachel MacRannolds, Virginia Boswell, Edna Stenberg, Mary Stenberg, Larry Bobel, and Dorothy Stenberg in 1942. (Courtesy of the Bobel estate.)

Beatrice Barnes (left) and Dorothy Stenberg sit at the foot of Germantown Hill on the newly created Clarksville Pike in 1945. (Courtesy of the Whites Creek Historical Society.)

This is a c. 1950 image of the Pleasant View Farmhouse with Allen Williams and hunting dog Thumper. The Williams family obtained the farm with land grants dating back to the Revolutionary War. (Courtesy of Angela Williams.)

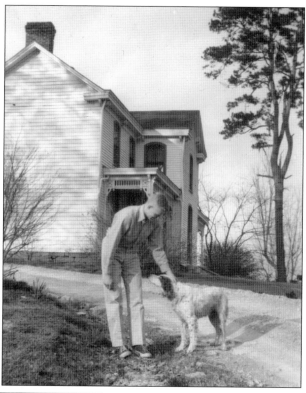

Seen here are Allen C. (left) and Wallace C. Williams with their dogs (from left to right) Jiminy Cricket, Thumper, and Bo the Bird Dog. The Williams brothers were avid hunters and fishermen in Whites Creek and nearby Crocker Springs Lake. Both Allen and Wallace graduated from Duncan Prep School and Vanderbilt University. (Courtesy of Angela Williams.)

BURTON'S COURT

GUEST REGISTRATION

NAME _____

STREET _____

CITY _____ STATE _____

NOTICE TO GUESTS

This property is privately owned and the management reserves the right to refuse service to anyone, and will not be responsible for accidents or injury to guests or for loss of money, jewelry or valuables of any kind.

PLEASE PAY IN ADVANCE

Room or Cottage No.	No. In Party	Make of Car	License	State
Date	Rate $	Clerk	Remarks	
	Tax if any			
	Amt. Paid $			

Pictured is a Burton's Tourist Court registration card. (Courtesy of Georgianna Burton Johnson.)

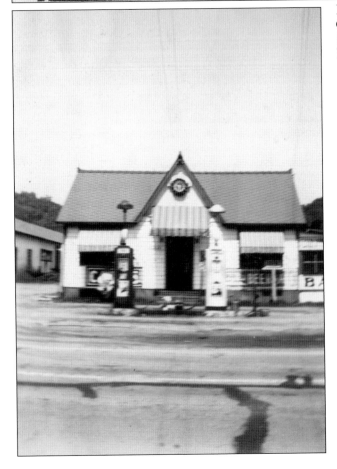

This is a photograph of the Burton Brothers Tourist Camp. James Burton sold homemade whiskey to customers in the restaurant. (Courtesy of Georgianna Burton Johnson.)

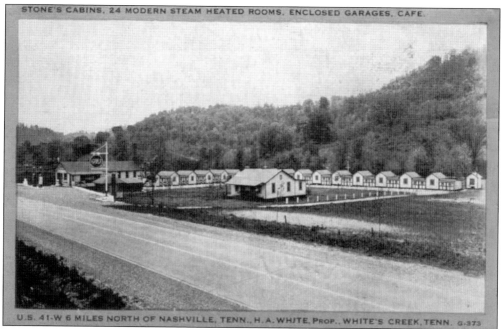

H.A White owned and operated Stone's Cabins, located off Clarksville Pike. The postcard seen here advertises 24 modern steam-heated rooms, enclosed garages, and a cafe. (Courtesy of George Ewing.)

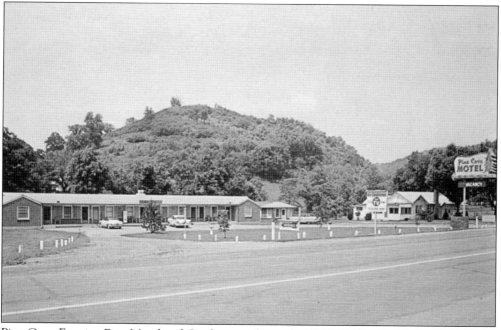

Pine Cone Evening Rest Motel and Gardens was located at 5019 Clarksville Highway. The back of this postcard describes the property: "Just minutes away from Grand Ole Opry and Country Music Hall of Fame, Convenient to Opryland USA, Old Hickory Lake and The Hermitage, Electric Heat, Combination tub and showers, family units." (Courtesy of George Ewing.)

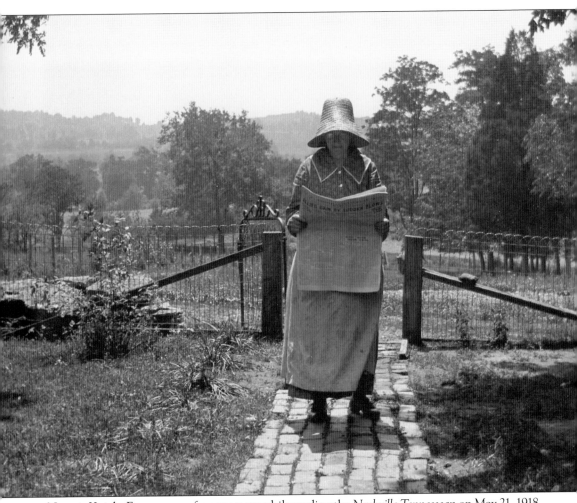

Nannie Knight Evans pauses for a moment while reading the *Nashville Tennessean* on May 21, 1918. The front-page headline reads "Allies Gain By Sudden Blows." (Courtesy of the Hudson estate.)

Three local men showcase
tailored suits of the era.
(Courtesy of the Hudson estate.)

Oliver Duke, son of Church
and Lelia Duke, enjoys rocking
outside in 1911. (Courtesy
of the Hudson estate.)

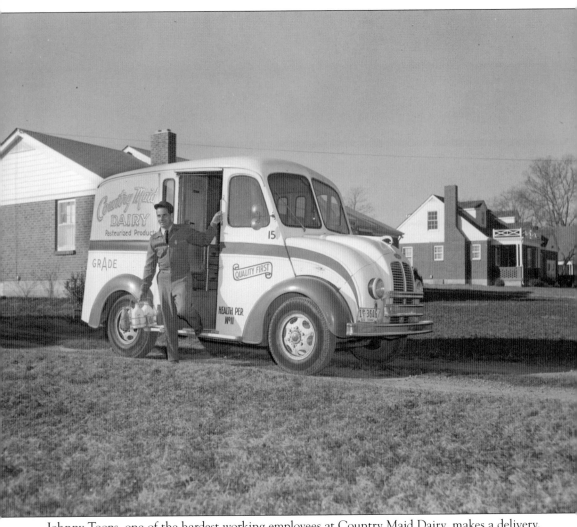

Johnny Toops, one of the hardest working employees at Country Maid Dairy, makes a delivery. His wife, Liz Toops, was a secretary at the dairy. (Courtesy of the Thompson estate.)

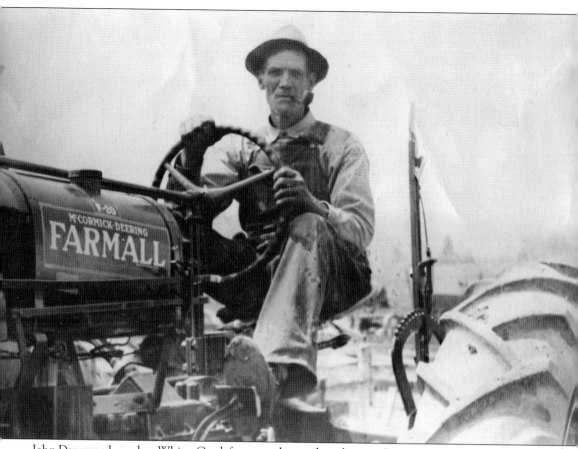

John Day was a legendary Whites Creek farmer and trusted employee at Country Maid Dairy. Day also worked at the Fred Johnson farm, which is now Fontanel. (Courtesy of the Thompson estate.)

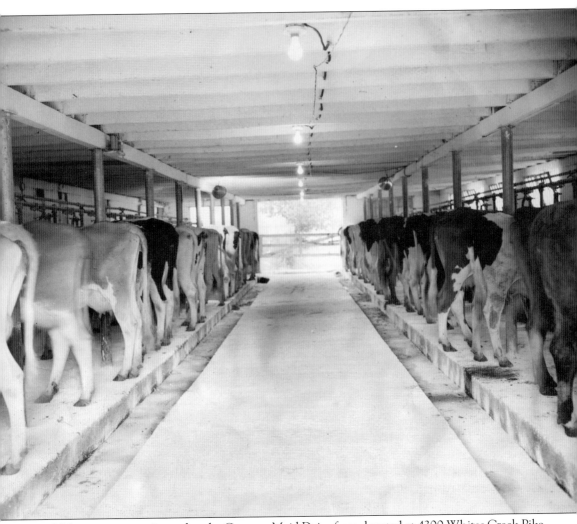

Holstein cows are pictured at the Country Maid Dairy farm, located at 4300 Whites Creek Pike. (Photograph by L.L. Tucker for the *Nashville Banner*, courtesy of the Thompson estate.)

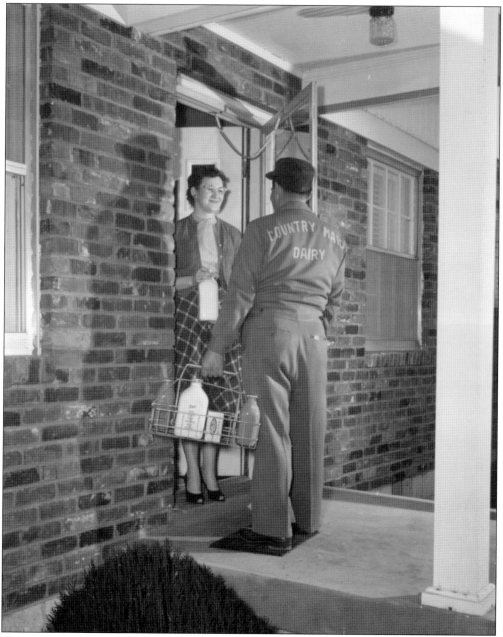

Here is another look at Johnny Toops, an indispensable employee of Country Maid Dairy, delivering milk. (Courtesy of the Thompson estate.)

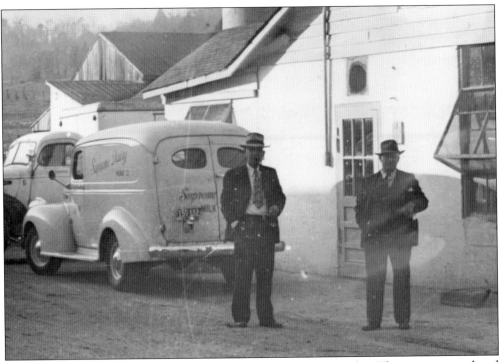

Supreme Dairy was the Springfield, Tennessee, location for another Thompson-owned and -operated dairy. Herman Thompson is pictured on the left as he meets with a business associate next to a Supreme Dairy automobile at the Country Maid Dairy on Whites Creek Pike. (Courtesy of the Thompson estate.)

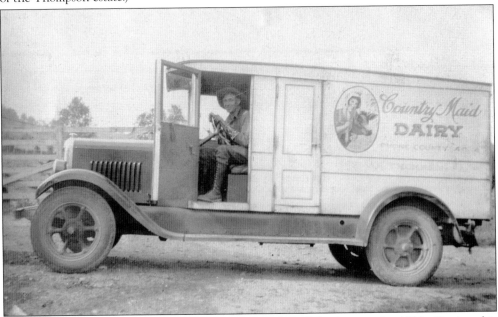

Herman Thompson is pictured on a truck at his Lickton Pike farm in the 1920s. During this time, he also owned a grocery store at 9th Avenue and Monroe Street in downtown Nashville. (Courtesy of the Thompson estate.)

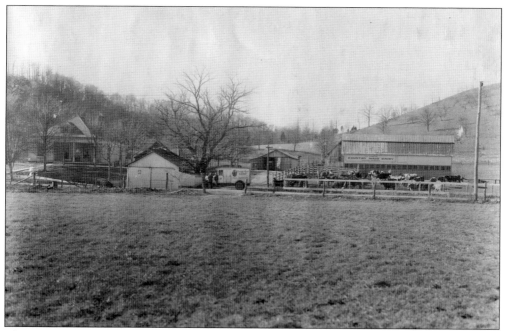

The Country Maid Dairy house and barn on Lickton Pike are pictured here in 1930. (Courtesy of the Thompson estate.)

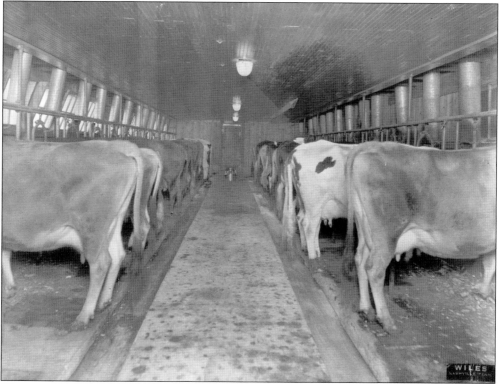

This is a typical scene in 1930 of cows being milked at the Country Maid Dairy on Lickton Pike. (Courtesy of the Thompson estate.)

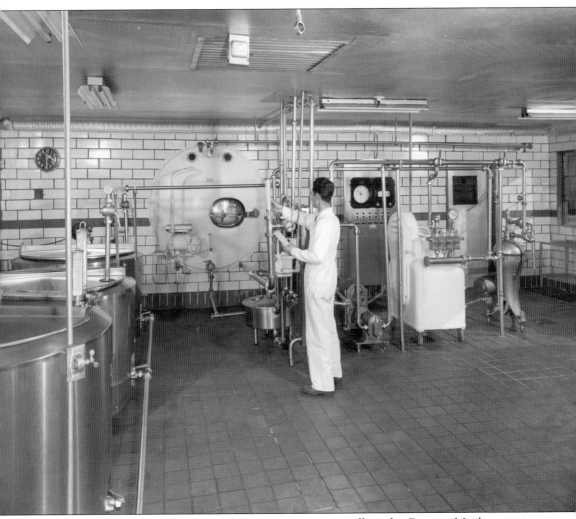

Reece Thompson, son of Herman Thompson, pasteurizes milk in the Country Maid processing plant. Reece was the resident mechanical engineer at the dairy, building and fixing all the machines used on the property. He was also well known throughout the region for his work in restoring classic automobiles. (Courtesy of the Thompson estate.)

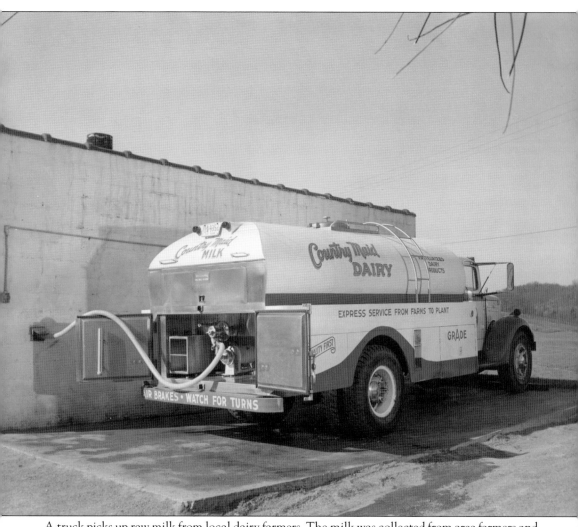

A truck picks up raw milk from local dairy farmers. The milk was collected from area farmers and brought back to the dairy to be pasteurized. (Courtesy of the Thompson estate.)

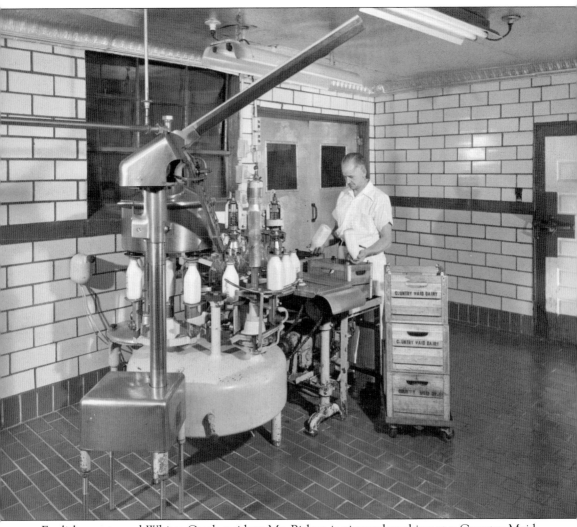

Englishman turned Whites Creek resident Mr. Bishop is pictured working at a Country Maid Dairy bottling machine. (Courtesy of the Thompson estate.)

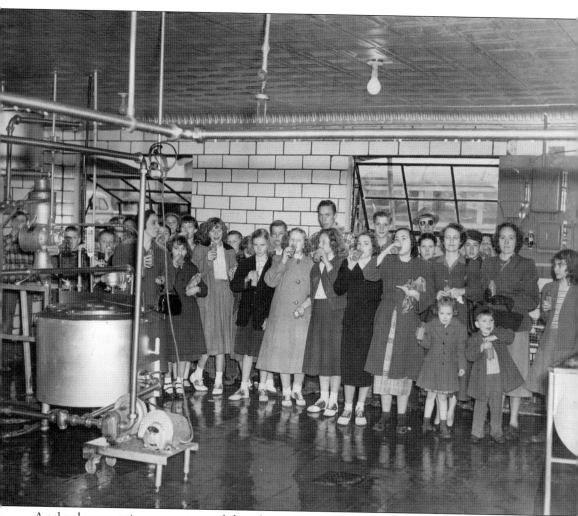

A school group enjoys a rare treat of chocolate milk on a field trip to the Country Maid Dairy. (Courtesy of the Thompson estate.)

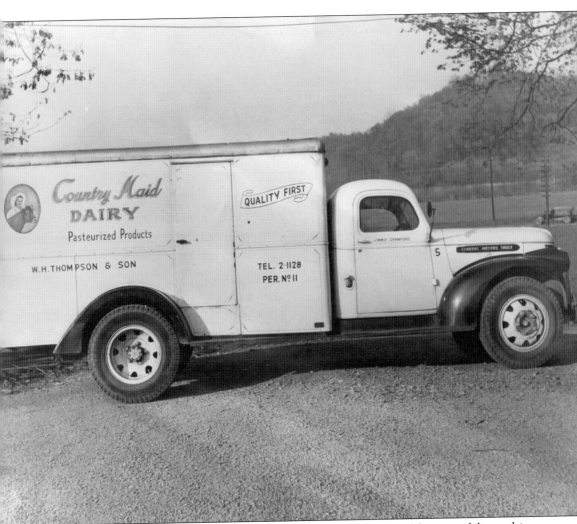

A 1940s Country Maid truck delivers milk to nearby residents. Some of the many delivery drivers were Hilary Binkley, Wesley Tucker, Harold Pratt, Austin Greer, Thomas Adcock, Jimmy Shelton, Alfred Evans, Walter Bosely, and Charles Pennington. The drivers began their day very early in the morning, loading up the trucks with heavy boxes of milk to be distributed all around the Nashville area. (Courtesy of the Thompson estate.)

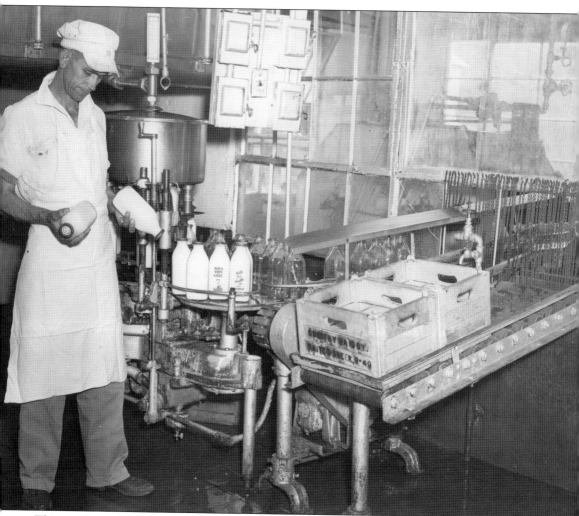

This is a September 1949 look at a bottling machine used at the Country Maid Dairy. (Courtesy of the Thompson estate.)

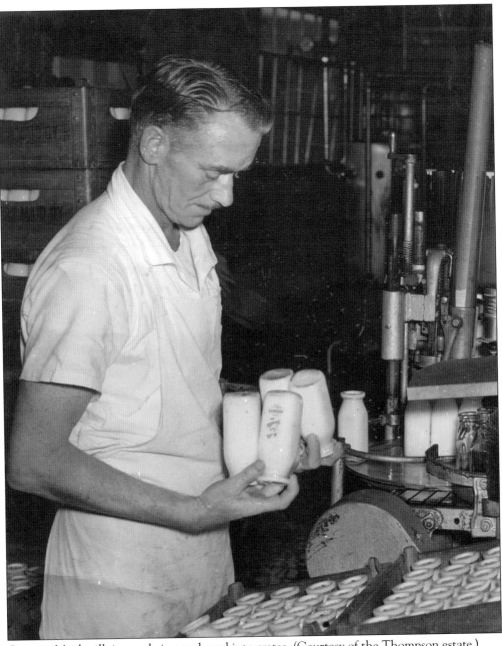

Country Maid milk is seen being packaged into crates. (Courtesy of the Thompson estate.)

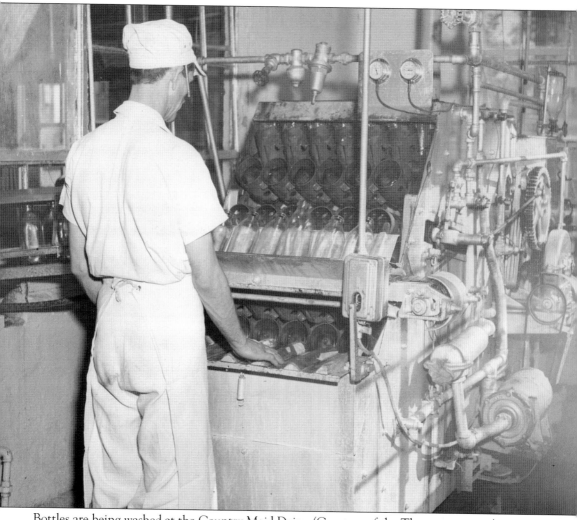

Bottles are being washed at the Country Maid Dairy. (Courtesy of the Thompson estate.)

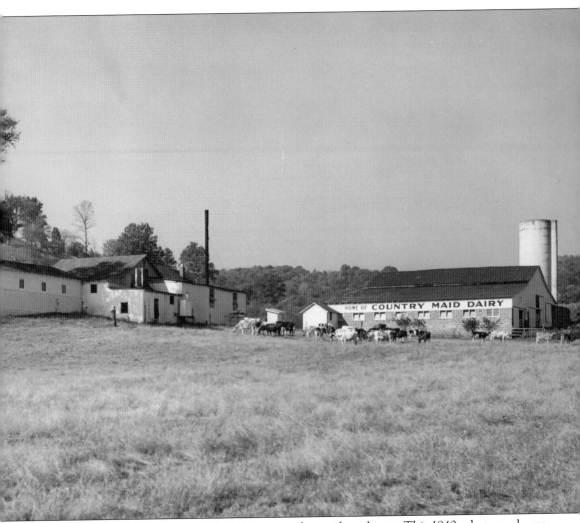

This is a view of the Country Maid Dairy, complete with outhouse. This 1940s photograph was taken before a second barn was added to the property. The dairy provided a career for several locals over the course of its operation, including Ruth Tolliver, Cliff Stephens, Red Mundy, and Harold McCracken. Wesley Tucker worked there from age 15 to age 75. Thomas Baker, Mr. Kendrick, Mr. Gillam, Mr. Rush, and Mr. Nieswander were all valued employees on the farm. (Courtesy of the Thompson estate.)

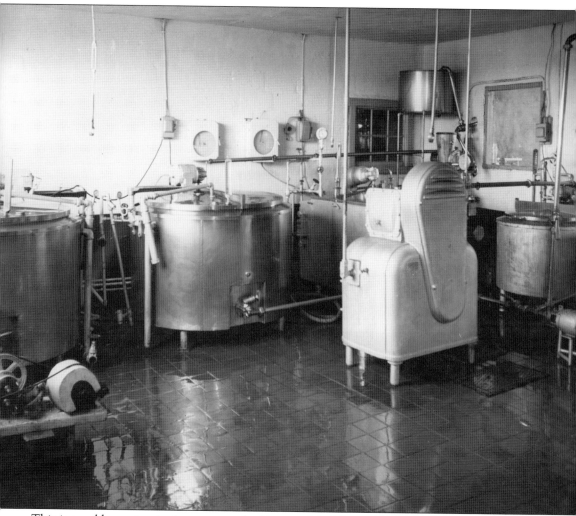

This is an older pasteurization setup at the Country Maid Dairy. The floor appears wet after a daily cleaning. (Courtesy of the Thompson estate.)

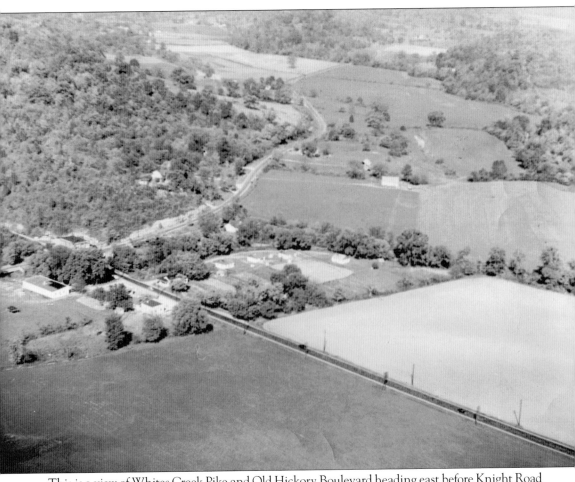

This is a view of Whites Creek Pike and Old Hickory Boulevard heading east before Knight Road was built. (Courtesy of the Thompson estate.)

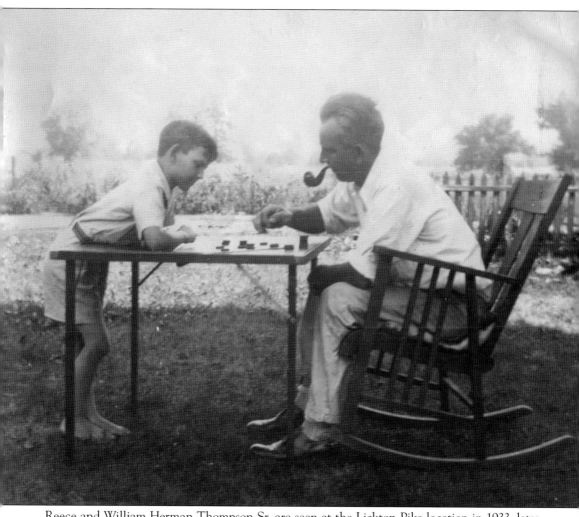

Reece and William Herman Thompson Sr. are seen at the Lickton Pike location in 1933, later owned by musician Boots Randolph. (Courtesy of the Thompson estate.)

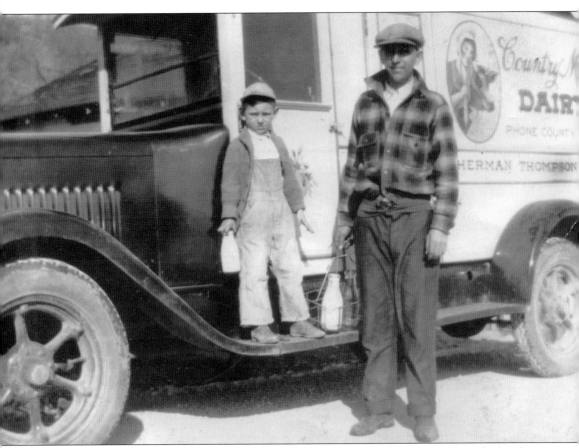

Reece and William Herman Thompson Sr. proudly pose next to their 1928 GMC truck. On the back of the photograph, Reece Thompson wrote, "I think a 1928 GMC (yellow coach) truck with a 6 cylinder Buick engine. GMC's could be ordered with various GM engines, and dad (Herman Thompson) thought Buick was best. I remember heat control on the dash and having a hard time holding the milk bottle in one hand. The body was built on chassis by a builder on Woodland Street bridge, on the East side, about halfway up on the right. I think it's ideal." (Courtesy of the Thompson estate.)

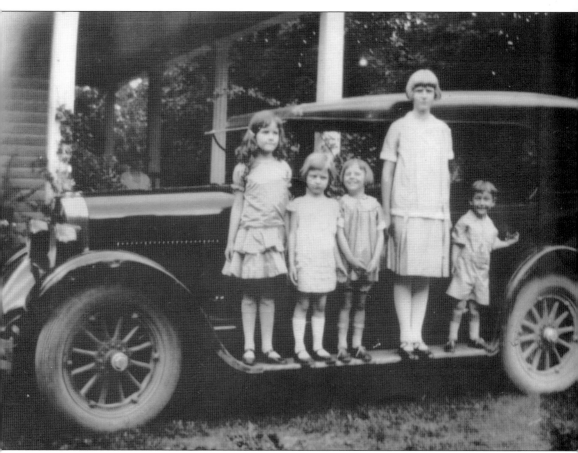

Reece Thompson (on the right) is pictured alongside friends from the Peeler family, hiding from turkeys in 1926. Reece Thompson wrote on the back of the photograph, "This is the car I hid under the dashboard because mother drove so fast coming back from the circus. This is the car that the turkey strutted around and scared me so bad." (Courtesy of the Thompson estate.)

William Herman Thompson was born November 12, 1894, in Hickman County, Tennessee. In 1916, he married Odie Harris. Herman first bought a dairy on Lickton Pike in 1930 and then bought the Neuhoff homestead at 4300 Whites Creek Pike in 1941, converting it to a successful dairy farm called Country Maid. (Courtesy of the Thompson estate.)

Herman and Odie Thompson, married in 1916, moved to a Lickton Pike home in Whites Creek later owned by saxophonist Boots Randolph. (Courtesy of the Thompson estate.)

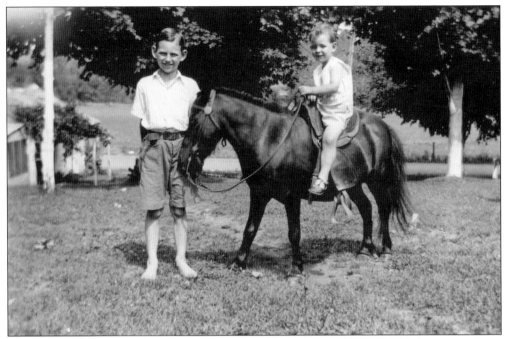

Reece (left) and William Herman "Buddy" Thompson Jr., pictured here in 1933, grew up doing all the chores they could—packing silos, lifting bales of hay from fields to barns, and working on early-morning delivery trucks. They carried on the tradition of the dairy until Country Maid was sold in the mid-1970s to Purity Milk Company. (Courtesy of the Thompson estate.)

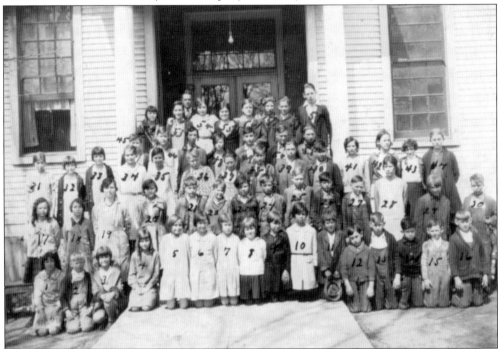

Reece Thompson is among the students pictured in this 1931 class photograph at Lickton School. (Courtesy of the Thompson estate.)

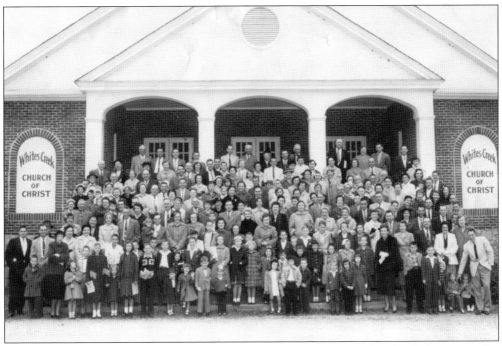

Herman Thompson dug the basement of the original Whites Creek Church of Christ using his mules and served as an elder in the congregation. Herman and Odie are seen here in the center of the back row in 1955. (Courtesy of the Thompson estate.)

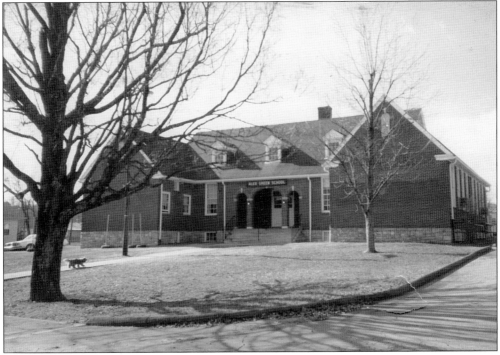

Many generations of Whites Creek students have memories of the Alex Green School. (Courtesy of the Thompson estate.)

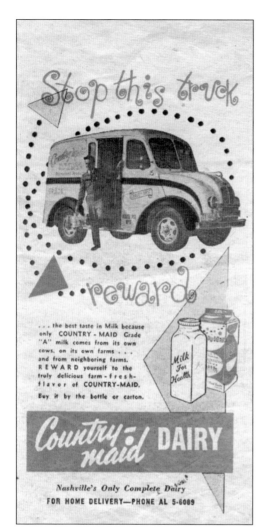

This Country Maid Dairy advertisement was published in the mid-1950s. (Courtesy of the Thompson estate.)

A Country Maid Dairy advertisement, published June 16, 1957, is pictured here. (Courtesy of the Thompson estate.)

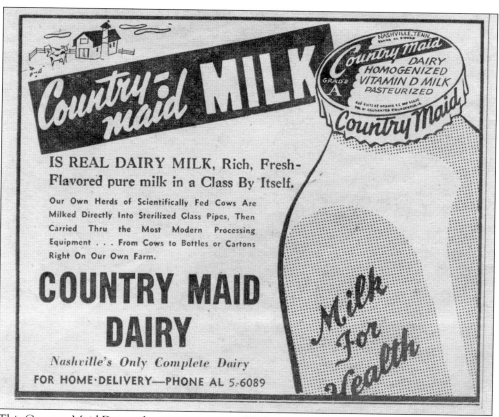

This Country Maid Dairy advertisement was published June 3, 1956, in the *Nashville Tennessean* magazine. (Courtesy of the Thompson estate.)

Odie Harris Thompson and William Herman Thompson Jr. pose for a photograph with their chickens. (Courtesy of the Thompson estate.)

Reece Thompson enjoyed his time growing up at the Lickton Pike dairy, pictured here in 1930. (Courtesy of the Thompson estate.)

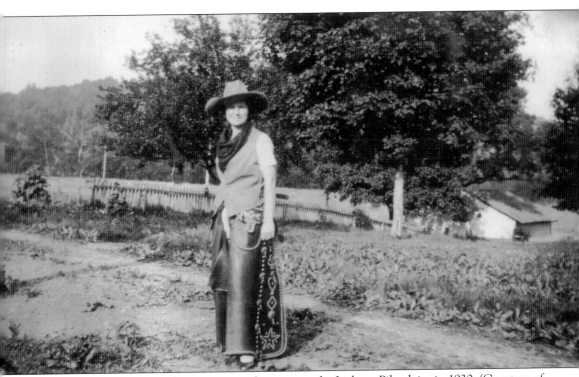

Odie Thompson is seen here wearing riding gear at the Lickton Pike dairy in 1930. (Courtesy of the Thompson estate.)

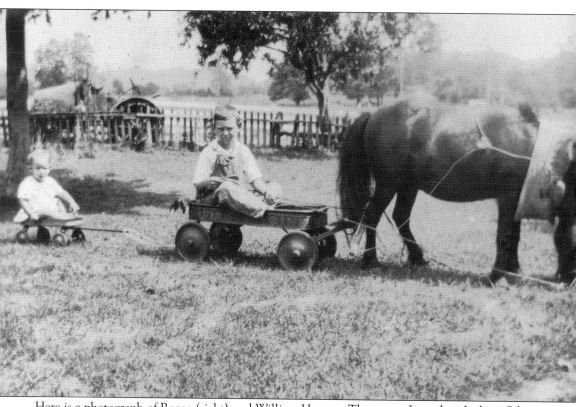

Here is a photograph of Reece (right) and William Herman Thompson Jr. at their Lickton Pike home, driving Proctor the pony in 1930. (Courtesy of the Thompson estate.)

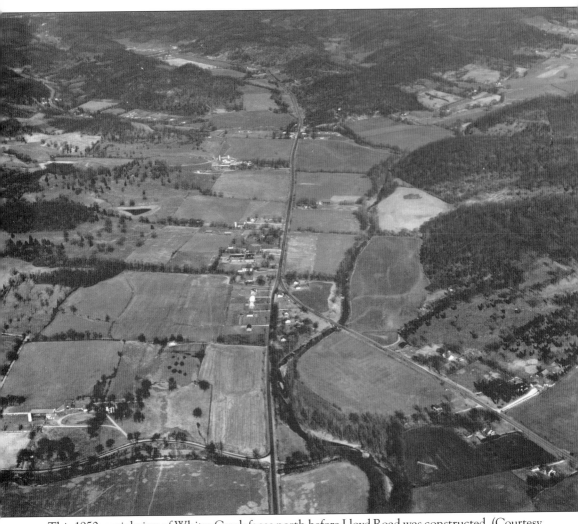

This 1950s aerial view of Whites Creek faces north before Lloyd Road was constructed. (Courtesy of the Thompson estate.)

This aerial view shows the vast 220 acres of Fontanel property. Live concerts are held at the 4,500-capacity amphitheater, and other attractions include AdventureWorks Ziplines, Prichard's Distillery and Natchez Hills Winery, and the award-winning Cafe Fontanella. The luxurious Inn at Fontanel offers accommodations with six suites. (Courtesy of Fontanel.)

The Mansion at Fontanel is the former home of Country Music Hall of Fame member Barbara Mandrell. Built by her husband, Ken Dudney, the mansion is a 33,000-square-foot log home situated in the rolling hills of the Whites Creek Valley. Guided tours are available seven days a week. The estate is currently decorated with displays and memorabilia from numerous country music artists. (Courtesy of Fontanel.)

DISCOVER THOUSANDS OF LOCAL HISTORY BOOKS FEATURING MILLIONS OF VINTAGE IMAGES

Arcadia Publishing, the leading local history publisher in the United States, is committed to making history accessible and meaningful through publishing books that celebrate and preserve the heritage of America's people and places.

Find more books like this at
www.arcadiapublishing.com

Search for your hometown history, your old stomping grounds, and even your favorite sports team.

Consistent with our mission to preserve history on a local level, this book was printed in South Carolina on American-made paper and manufactured entirely in the United States. Products carrying the accredited Forest Stewardship Council (FSC) label are printed on 100 percent FSC-certified paper.

MADE IN THE USA